The **Kodak** Most Basic Book of Digital Nature Photography

Russell Graves

Kodak
Books

Published by Lark Books
A Division of Sterling Publishing Co., Inc.
New York / London

Editor: Haley Pritchard
Art Director: Tom Metcalf
Cover Designer: Thom Gaines

Library of Congress Cataloging-in-Publication Data

Graves, Russell A., 1969-
 The Kodak most basic book of digital nature photography / Russell A.
Graves. — 1st ed.
 p. cm.
 Includes index.
 ISBN-13: 978-1-60059-141-9 (pb-trade pbk. : alk. paper)
 ISBN-10: 1-60059-141-8 (pb-trade pbk. : alk. paper)
 1. Nature photography. 2. Photography—Digital techniques. I. Title.
 TR721.G73 2008
 779'.3—dc22
 2007013522

10 9 8 7 6 5 4 3 2 1

First Edition

Published by Lark Books, A Division of Sterling Publishing Co., Inc.
387 Park Avenue South, New York, N.Y. 10016

Text © 2008, Eastman Kodak Company
Photography © 2008, Russell Graves unless otherwise specified

Distributed in Canada by Sterling Publishing,
c/o Canadian Manda Group, 165 Dufferin Street Toronto, Ontario, Canada M6K 3H6

Distributed in the United Kingdom by GMC Distribution Services, Castle Place, 166 High Street, Lewes, East Sussex, England BN7 1XU

Distributed in Australia by Capricorn Link (Australia) Pty Ltd.,
P.O. Box 704, Windsor, NSW 2756 Australia

If you have questions or comments about this book, please contact:
Lark Books
67 Broadway
Asheville, NC 28801
(828) 253-0467

Manufactured in China

ISBN 13: 978-1-60059-141-9
ISBN 10: 1-60059-141-8

For information about custom editions, special sales, premium and corporate purchases, please contact
Sterling Special Sales Department at 800-805-5489 or specialsales@sterlingpub.com.

Dedication

For my brother Bubba who gave me
my first camera, and my brother
Larry who has always been one of
my biggest fans.

Acknowledgements

Several people deserve recognition
for their part in helping me com-
plete this book. First, my wife and
two kids who support me in my
endeavors even when it is not easy;
for that I am forever grateful.

I am also blessed to be friends with
landowners like Tom Hudson, Steve
Bird, Bobby Hart, Burl and Mary
Brim, Jason Smith, Dr. Howard Head,
Royce Siebman, Glen and Mary
Sanders, and others and who have
generously provided access to their
land. Finally, I would be remiss if I
didn't mention the photographers
of the Texas Photo Forum who pro-
vided valuable suggestions as to the
content of this book. Many on the
forum are beginning photographers,
and their questions gave me a fresh
perspective on how to address the
concerns of those who are just get-
ting in to nature photography.

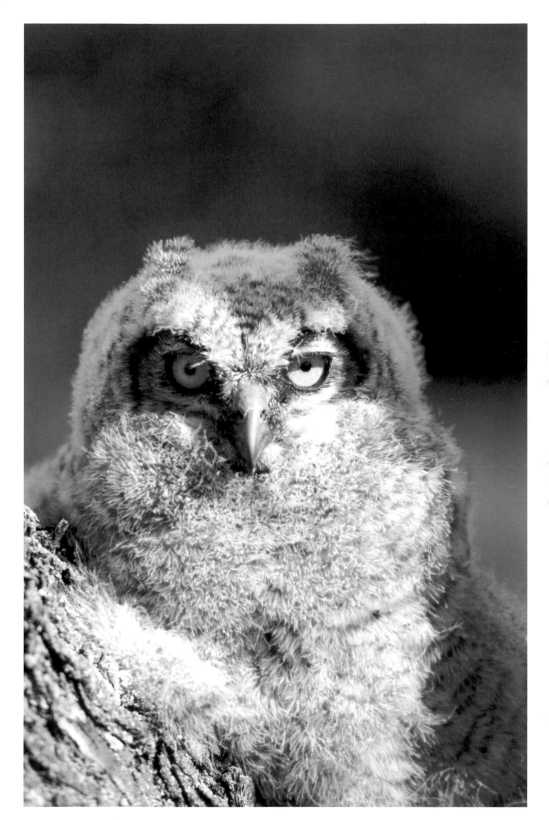

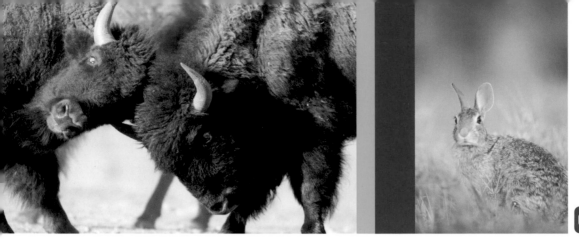

contents

introduction...8

1 Equipment Basics ..10

 Digital Point-and-Shoots and
 Advanced Compact Digital Cameras11

 Digital SLRs...13

 What to Look For ...14

 A Wide Variety of Accessories.......................14

 Focal Lengths and Zoom Capabilities14

 Number of Megapixels14

 Memory Cards...15

 Lenses...16

 Must-Have Accessories18

 Flash ..18

 Extension Tube ...18

 Shutter Release Cord19

 Photo Backpack...19

 Tripod...19

 Putting Together a Gear Package........................20

 Country Hike Scenario...................................20

 Basic Wildlife Scenario21

 Stationary Wildlife Photography Scenario22

 Things You'll Need at Home22

 Home Computer..22

 External Hard Drive.......................................23

 Portable Storage Device23

 Printer ..24

 Debunking Digital Myths24

 Myth: Megapixels Equal Photo Quality24

 Myth: TIFF Files are Superior to JPEGs25

 A Word About RAW Files......................................26

 Dots-Per-Inch (DPI) ..27

2 Exposure, Composition, and Technique..................28

 Exposure Explained...29

 Shutter Speed ..30

 Aperture...31

 Demystifying Depth of Field32

 ISO Sensitivity..34

 Common Outdoor Exposure Problems...................34

 The Histogram ..35

 Compose Like the Pros..36

 Step One: Get Close......................................36

 Step Two: Keep the Sun at Your Back.................37

 Step Three: Use the Rule of Thirds37

 The Human Factor...38

 Ten Ways to Improve Your Photography38

 Rock Steady—Take Sharp Pictures
 without a Tripod ...41

 Proper Camera Handling................................41

 Use what Nature Provides42

 Technology to the Rescue...............................42

 The Bottom Line...43

3 Lessons in the Field ...44

 Equipment Extras ...45

 Reflector...45

 Flash Cord ..45

 Monopod..46

Beanbag Rest ...46

Flash Extender ...46

Five In-the-Field "Must Haves"47

Using Flash Outdoors ...49

Making Colors Pop ..49

Freezing Action ...50

Blurring Action ...50

Flash on the Water51

Creative Shutter Speeds53

Fast Shutter Speeds53

Slow Shutter Speeds54

Nature Photography Quick Tips55

Landscapes ...55

Wildlife ..56

Macro ..57

People in the Outdoors58

Practice ..59

4 Working with People, Places, and Animals60

Finding Wildlife ...61

Backyard Photography ..62

Taking Pictures at the Zoo63

Shooting on Public Land64

Shooting on Private Land65

Ten Ways to Get Invited Back66

Using Feeders to Attract Wildlife68

Blinds and Camouflage ...69

Hiding in Plain Sight70

Making Your Own Blind72

Dress for Success ..73

Hide Where They Live73

Dressing Up ..74

Dressing Down ...75

Selecting a Pattern75

Using Decoys ...76

Turkeys ..76

Predators ..78

Deer ...78

Game Birds ...79

Waterfowl and Shorebirds80

5 Case Studies and Creating a Digital Workflow82

Case Study 1: The Mule Deer83

Case Study 2: The Running Buck84

Case Study 3: The Mourning Dove85

Case Study 4: Backyard Flowers86

Case Study 5: The Wading Crane87

Case Study 6: Tricky Exposures88

Case Study 7: Getting Low89

Case Study 8: Flying High90

Establishing a Digital Workflow91

Staying Organized in the Field91

After the Shoot ..92

Edit and Rename ..92

Download ..93

Basic Image-Processing93

Organize for Later Image Retrieval94

Color Management ...95

Conclusion ...95

index ...96

Introduction

I love taking pictures. For the past sixteen years, I've made photography a hobby, a passion, a lifestyle, and a profession. I can't think of another activity that would cause me to sacrifice so much sleep, travel so many miles, or brave such extremes in temperature and weather. Through the lens of my camera, I've seen some truly remarkable things, like a whitetail fawn taking its first steps, or the sun spilling over western landscapes that have remained nearly unchanged for thousands of years. Indeed, I come by my obsession honestly.

When I was a teenager living on a small northeast Texas cattle ranch, I can't count the number of times I was supposed to be checking cattle or fences when a deer, opossum, or some other woodland critter would divert my attention away from chores to exploring the natural world. Growing up in the country where the Texas Blackland Prairie Region meets the Post Oak Savannah region, I had plenty of wildlife to entertain me. All of those times spent exploring the land and its creatures helped shape an outdoor ethic and fascination for all things wild that I still carry with me today.

In my late teens, photography came to me through an old Vivitar camera given to me by my older brother. From the first rickety clank of the old camera, I was hooked. From the beginning, I knew that photography was a fantastic way to record the natural world in my little corner of Texas. Since then, I've never developed more than a passing interest in studio photography, but rather decided early on that I'd try to capitalize on natural light and let the outdoors be my studio.

The purpose of this book is to help you make your photographic technique fundamentally sound. In order to be a fundamentally sound photographer, it takes a mix of knowledge and vision. Knowledge helps you understand what to do and why when complex photographic problems come your way, and vision helps you create memorable images. Through these pages, my goal is for you to grasp the elements of photography that are common in nearly every great image you've ever seen. Whether your intentions are to one day be a pro or simply hone your existing skills, this book will help you on your way.

As a final note, I'd love to hear how you are doing. If you ever have any questions, want to chat, or send me an update on your progress, go to my website at www.russellgraves.com and send me an email. I'd love to hear from you.

Good Luck!

Getting started in nature photography is a matter of defining what kind of pictures you want to take. Shooting pictures of close-up subjects like flowers requires different camera settings—and different equipment if you're a digital SLR user—than shooting pictures of wildlife. If you are like me, you want to take pictures of everything outdoors. So does that mean that you need to run out and spend a ton of money to get all kinds of specialized equipment? Not at all. If you understand the various kinds of equipment available to you and how it matches your needs and goals, you can get started in shooting great nature pictures almost immediately. If you already have equipment on hand, this section will give you an idea of how to optimize what you're working with, as well as offer some suggestions as to what you might want to supplement your current tools with to get the best possible shots.

1

Equipment Basics

Digital Point-and-Shoots and Advanced Compact Digital Cameras

Digital point-and-shoot cameras are the most simple—and often the smallest—type of digital camera. Advanced compact digital cameras are a step up from digital point-and-shoots; they often have higher megapixel resolutions and an accessory hot shoe that can accept an external flash unit. While these types of digital cameras are fine for some applications in nature photography, overall, they will limit your picture taking. Digital SLR (DSLR) cameras that allow for interchangeable lenses are the ideal choice. However, with that said, digital point-and-shoot and advanced compact digital cameras are great for a lot of reasons. They are portable, work great for everyday snapshots, and are very affordable. So, let's say you want to get into digital nature photography and you either don't want to invest in DSLR equipment right off the bat, or you just want to get started with the digital point-and-shoot or advanced compact digital camera you've already got and upgrade from there.

Can you still use these types of cameras to take good nature pictures? The answer is yes. You'll just have more limitations than you would with a DSLR.

While the telephoto capabilities of either of these non-SLR digital camera types aren't as good as those of their DSLR counterparts, they will still zoom to some degree. Many of these cameras enable you to zoom up to 400mm or more without accessing the digital zoom feature, which should be avoided. (Digital zoom—as opposed to the optical zoom of the lens—is merely a digital crop of the subject or scene that cuts pixels in order to produce a closer rendering.) However, even greater focal lengths are required to catch some of the more skittish wildlife subjects that tend to stay farther from the camera. On the other hand, if your interests lie mainly in the close-up or landscape sides of digital nature photography, digital point-and-shoots and advanced compact digital cameras are much more suited to those areas.

These cameras generally do best in situations when you don't need a fast response time. They typically have a slight delay from the time you press the shutter button to when the shutter is released and the pixels are exposed to light. This delay is called shutter lag. (Most DLSR cameras have miniscule or no shutter lag, so they work very well for fast action photography.)

As for their imaging capabilities, the latest digital point-and-shoot and advanced compact digital cameras do quite well in the fields of color rendition and picture quality at enlarged sizes. The quality of the digital sensors in these cameras evolves every day as manufacturers continue to make advances and close the quality gap between them and digital SLR cameras. Here are a few other things to keep in mind if you are specifically looking to buy one of these smaller digital cameras:

• Find a camera that uses common batteries: Nothing is more frustrating than having dead batteries in a small town and not being able to find batteries to fit your camera.

Stay with cameras that can use AA or AAA batteries and chances are that you'll always be able to power your camera.

• Megapixels matter: The rule is fairly simple: The more megapixels, the higher the resolution of the image. (See pages 14–15 for more about megapixels.)

• Look for good optical zoom range: Your camera's optical zoom capability should match the subject matter that you want to photograph. Digital zooms become a crutch and

make people sacrifice proper technique to produce a lower resolution image. Besides, you can always crop the image later using image-processing software.

Overall, for the casual shooter, digital point-and-shoot and advanced compact digital cameras do have a place. They are lightweight, easy to operate, and are relatively inexpensive. Their quality of build and the quality of images they produce are outstanding, but they lack the room to grow as your skill grows. If your intent is to be a casual shooter, these cameras may be all you need. However, if you plan to improve and hone your skills, DSLRs are the only way to go.

Digital SLRs

By far, the very best cameras for nature photography are digital single-lens-reflex (DSLR) cameras. They have many advantages over other types of consumer level digital cameras, including the ability to interchange lenses, use a wide variety of camera filters, and accept flash units and other accessories. Plus, they are just as easy to use as other types of digital cameras—even digital point-and-shoots—while having a wide range of additional features and quality options typically not available with non-SLR type cameras.

DSLRs are relatively inexpensive, especially in comparison with some of the high-end advanced digital compact cameras. And, as the old adage says, you get what you pay for. Spend that bit more and see how quickly the quality of your images improves. Once you start down the DSLR path, if you stick with the same brand of camera, it's easy for your gear to grow with your skill level. It works like this: Buy an entry level DSLR with a lens or two and some accessories, and as your skill level improves down the

road, you may want to get a more advanced camera. If you stick with the same camera brand, you can keep all the lenses and accessories you've already invested in and just upgrade the camera body! So what brand should you get? All major camera brands offer exciting features and accessories, therefore, I contend that brand really doesn't matter. What does matter is that you learn how to use the camera and start taking great pictures.

What to Look For

Although opinions vary, I think there are several things you should look for when buying a digital camera. These things will help you decide which camera is best for you and whether it will grow with you as your skill level grows.

A Wide Variety of Accessories

Sometimes, specialized photos call for specialized gear. For example, macro and close-up photography require that your lens can focus mere inches away from the subject. Some manufacturers even make a macro flash that can sit on the front of a DSLR lens. Be sure that the camera you invest in has accessory options that suit the style or styles of photography that you enjoy most. For digital point-and-shoot and advanced digital compact users, look for a camera that has an accessory hot shoe, as well as one that can be fitted with an adapter piece that allows you to use filters or additional lens attachments.

Focal Lengths and Zoom Capabilities

For photographing wildlife, you will need access to telephoto focal lengths. For shooting landscapes, wide-angle focal lengths that can take in a lot of scenery are generally the rule. So, be sure to invest in

quality lenses that cover this full spectrum of focal lengths. If you are a DSLR user and are able to invest in multiple lenses, the two zoom lenses I would opt for would be a 28-70mm zoom and a 75-300mm zoom. The 28-70mm is a wide-angle lens at the 28mm range and is a short telephoto at the 70mm setting. The 75-300mm zoom picks up where the other lens leaves off and will provide ample zoom for shooting wildlife photos. For digital point-and-shoot and advanced digital compact users, be sure that the lens on your camera covers focal lengths from very wide to fairly long without accessing the digital zoom feature. (See page 11 for information about digital versus optical zoom.)

Number of Megapixels

One of the first things that new digital camera owners learn is that the number of megapixels the camera has matters. Megapixels are the number of pixels contained on the light gathering image sensor inside a camera. One megapixel equals one million pixels. Therefore, a six-megapixel camera has 6 million pixels. Simply put, pixels capture color information and transform light into computer language. Therefore, as a general guideline, more pixels mean more color information can be captured with the image. And the more detailed the color information, the bigger prints you can make. The overall number of megapixels a camera has is referred to as its resolution. The higher the resolution an image has, the crisper and more lifelike the image will be.

Here's a general rundown of how a camera's megapixel count affects print size:

Megapixels	Maximum High-Quality Print Size
5	11 x 14 inches (B4)
4	9 x 12 inches (C4)
3	8 x 10 inches (B5)
2	5 x 7 inches (B6)

listed here, but the 1 or 2 gigabyte (GB) cards are a nice size to start off with. For example, a 2 GB card will hold over 500 high-resolution JPEG images from a digital camera with an 8.2 megapixel sensor—plenty to be sure that you won't have to censor your picture taking on a day out in the field.

Memory Cards

Memory cards are the recording media onto which your digital camera saves image files. There are several different types of memory cards on the market today, and though they are slightly different in size and appearance, they all essentially work the same way. The kind you use will depend on what your specific camera model works with. Some digital cameras are even capable of using two different kinds of cards. Check your camera manual to be sure what you need before purchasing additional memory.

Memory capacity on these cards varies but common sizes include 250 megabytes, 500 megabytes, and 1 or 2 gigabyte cards. You can buy bigger capacity cards as well as smaller capacity cards than those

Lenses

If you are shooting with a DSLR (as opposed to an advanced digital compact or digital point-and-shoot camera that does not allow for interchangeable lenses), there are many different lenses available to you in today's digital photography market. Here are a few suggestions that might help you decide what lenses would make the best additions to your camera outfit.

A wide-angle zoom – For dynamic landscape images, go wide. Select a lens that covers a nice range of focal lengths. I suggest an 18mm – 55mm zoom.

A telephoto zoom – If you want to shoot wildlife, you definitely want to buy a telephoto lens. Again, I suggest a zoom lens that will work in many different scenarios. Try a 70mm – 200mm; this lens is

extremely versatile. On the 70mm end, you can frame an animal in its habitat and get a great environmental shot. Then, zoom in to 200mm and get a great head and shoulders shot that really captures the animal's characteristics.

A super telephoto lens – If you can afford it when you are first starting out, get a 300mm lens. A 300mm lens is a great lens for large wildlife and will also work well for birds, especially with a 2X teleconverter.

A macro lens – For extreme close-up work, I like to use a 50mm macro lens. Although these lenses come in other focal lengths, I prefer the 50mm because it serves as a normal focal length lens with excellent close-up focal qualities. With this macro lens, you can get great close-ups of flowers or other small objects.

A teleconverter – If I had to buy just one, I'd get a 2X converter. Add the 2X to the two telephoto lenses mentioned in this list and you can get close enough to capture most wildlife species.

The overriding rule on lens selection is to buy the very best lenses you can afford. With lenses, you get what you pay for; buy good quality lenses and your results will reciprocate. The best advice I can give you

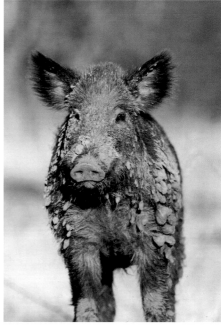

when selecting lenses is to stick with lenses manufactured by your camera maker. These companies have exacting standards and put a great deal of emphasis on quality control. Ultimately, they know that their reputation rides on the quality of their products.

Must-Have Accessories

Okay, you've got a digital camera with a lens (or lenses) that covers the full spectrum of focal length ranges from wide-angle to telephoto. The next thing to do to round out your digital photography gear and ensure great results for years to come is to add some or all of the following accessories.

Flash

Although many digital cameras with a built-in flash, you should ideally add an external flash unit to your setup. Some digital point-and-shoot cameras don't have a hot shoe to allow for an external flash unit, but quality advanced digital compact cameras most often do. A good external flash unit will help to brighten the color of your subjects and fill in unwanted shadow areas with light. (For more information about using flash, see pages 49–25.)

Extension Tube

For those of you who have DSLRs, extension tubes are a great way to enable a telephoto lens to act like a macro lens. Extension tubes look like teleconverters with one curious difference: They have no glass. These glassless tubes mount onto the camera just like a lens, and a lens is then mounted on top of the

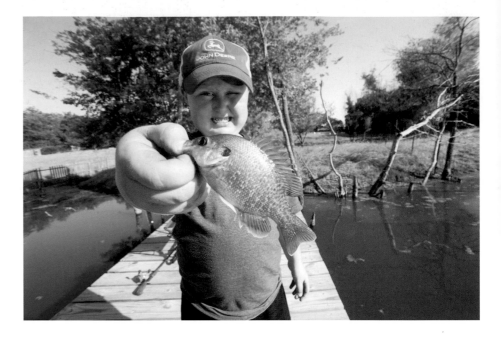

extension tube. When added between a telephoto lens and the camera, the lens' minimum focusing distance is reduced and the lens acts like a macro.

Suppose you are taking pictures of tiny birds in your backyard and you can get about ten feet (approximately 3 meters) from your feeder, but your super-telephoto lens will only focus down to 13 feet (about 4 meters) away. Add a small extension tube, like a 12mm, and you'll be able to focus as close as six feet (1.8 meters) away. In short, extension tubes are an inexpensive means to adding versatility to your lens collection.

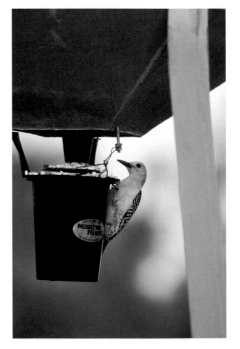

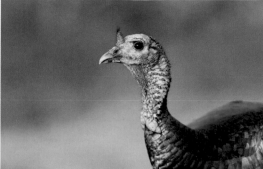

Shutter Release Cord

A shutter release cord attaches to your camera and allows you to trip the shutter without actually pressing the shutter release button. As such, this accessory has a few cool advantages. First, a shutter release cord is great for slow exposures where touching the camera could result in vibrations that will leave your pictures soft and blurry. Next, they allow you to leave the shutter open for extended periods of time in order to do long exposure techniques. Additionally, if you buy a shutter release cord that's long enough, you can even set your camera on a tripod and fire the camera remotely from a few feet away.

Photo Backpack

Since nature photography is an active undertaking, you need a way to carry your gear that will protect it from the elements, pad it against bumps, and make it easy to tote with you. Although some people like vests, I prefer a camera backpack. A good photo backpack will be padded, comfortable to carry, water resistant, and have movable internal partitions that allow you to change the configuration and customize it to any type of outing.

Tripod

One of the most important pieces of equipment you can buy aside from your camera and lenses is a good tripod. Cheap tripods are often the weak link to getting top

quality shots when using a telephoto lens or shooting long exposures. In digital photography, the name of the game is sharp images, and your ability to produce sharp images is compromised if you don't have a good tripod that can hold your camera and lens steady in wind and on uneven ground.

When buying a tripod, look for one that is lightweight. Most good tripods are made from tubular aluminum or tubes of carbon fiber. While aluminum is light, carbon fiber tripods are even lighter (although more expensive). Both materials are rock solid when incorporated into tripod legs.

Look for a tripod that comes without a head. The best tripods come as just legs and you can add the head of your choice. When selecting a tripod, try to buy one that extends tall enough to allow you to stand upright while using it; a long day of shooting is much more

enjoyable when you don't have to stoop over to take every picture. Conversely, choose a tripod that has legs you can spread way out to get the tripod low to the ground; you'll want the ability to take advantage of unique angles.

One last thing to look for when choosing a tripod is how the legs lock. I like locking units that have a little bulk to them so that I can adjust the legs while wearing gloves. The bulk of my wildlife photography is in cold weather, so being able to operate my gear with gloves on is extremely important to me.

On the subject of tripod heads, most three-axis pan and tilt tripod heads are too slow and cumbersome for nature photographers. Ball heads are preferable, as they have a single lever or knob that locks the head in place (as opposed to the three separate locks of the pan and tilt tripod heads). One twist and the head can move in an infinite number of directions along your tripod's axis.

Putting Together a Gear Package

Now you have all of your gear and you are ready to go out into the field, but you may be wondering which equipment to bring for which kind of shooting expedition. The good news is that selecting the right equipment for the job isn't all that complicated. You simply have to think about your goals and execute a plan. With weight and space being a factor, the following are a few common-sense setups that have worked for me. For those of you who are not shooting with a digital SLR camera, your pack will be much lighter and not include the additional lenses and accessories that are specifically for use with DSLRs.

Country Hike Scenario

While hiking, I like to travel light. Since most of my wildlife photography is done either stationary or from a vehicle, if I am hiking, I usually plan to do landscape photography. Therefore, this is how I would pack:

 Camera
 Extra memory cards
 Tripod

And for DSLR users:
 Wide-angle zoom lens
 Macro lens
 Telephoto zoom lens

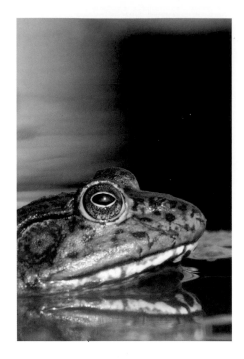

If you have a DSLR and have invested in multiple lenses, the country hike scenario is a perfect time to employ the three-lens setup outlined here. You can shoot scenic vistas with the wide-angle lens, focus on wildflowers with the macro lens, and shoot some great compressed landscapes with the telephoto lens. Of course, you could also use a single zoom lens that encompasses most of these focal length ranges, such as a 28 – 105mm lens, and bring along a teleconverter or an extension tube to supplement your lens' capabilities. Both macro and telephoto photography depend a great deal on the steadiness of a tripod, so having it along in this scenario is key.

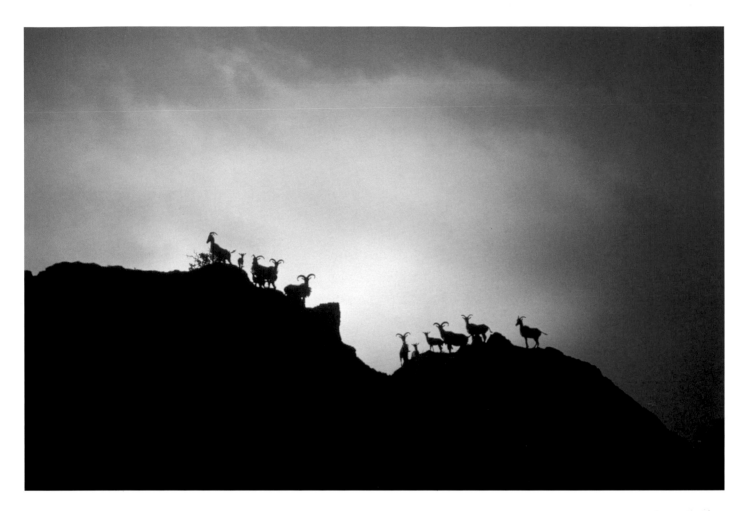

Basic Wildlife Scenario

This is another scenario where portability is key. In the backpack, I am likely to pack these items:

Camera
Extra memory cards
Flash
Tripod

And for DSLR users:
Macro lens
Telephoto zoom lens
Teleconverter
Extension tubes

This photo package, like the country hike package, is very versatile and easy to carry. You can use the telephoto zoom to get some great wildlife images, and if you're using a DSLR, try putting a 2X teleconverter on the lens to double your magnification. Conversely, you can pair that same lens with an extension tube to do macro work if you don't own or don't wish to carry a separate macro lens. Use flash to add a pop of color to your scenes, particularly if the sun is high overhead. And, of course, packing the tripod is handy for rock solid support when you need it.

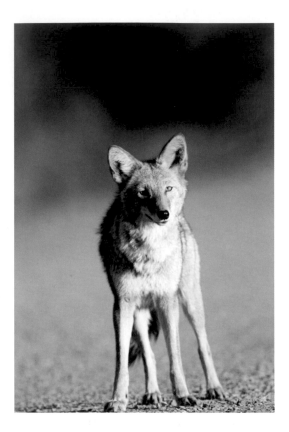

This setup is geared towards optimum magnification as evidenced by the selection of the super telephoto lens and teleconverter. For those of you who aren't shooting with a DSLR, plan to use the highest end of your zoom range and leave the lens extended when possible to be ready to shoot when an appropriate subject comes into view. A shutter release cord is ideal for this scenario, as it allows you to minimize camera movement at these telephoto focal lengths (see page 19 for more about shutter release cords). Handheld shots at focal lengths over 200mm are at a severe risk for being ruined by hand shake so, above all, plan to use a tripod.

(see page 19 for more about shutter release cords)

Things You'll Need at Home

An in-depth look at image-processing is beyond the scope of this book. However, Lark Books has many great titles that can help you build your digital photography knowledge and skills. We will spend a little time here on the subject of the equipment you will need for your "digital darkroom," but keep in mind that technology changes quickly and you should be sure to research the latest information about these products when it comes time for you to gear up.

photography is truly a marriage of photography and computer technology, so no digital photography hobbyist can consider themselves complete without these in-home and in-the-field accessories. With that disclaimer out of the way, here are some things to think about.

Home Computer

There are many opinions as to what kind of computer setup is optimal, but a computer with at least 1 gigabyte of RAM, a 2 gigahertz processor, about a 240 gigabyte hard drive for ample storage, and some kind of image-processing software will get you started. Image-processing programs help you perform many tasks, like cropping images, color correcting, resizing, renaming, and cataloging your digital collection. As I mentioned earlier, in-depth coverage of image-processing techniques is beyond the scope of this book, so check out one of Lark Books' other titles for great tips on these and other photography related subjects.

Stationary Wildlife Photography Scenario

Here, portability isn't as much of an issue. You'll be stationary most of the day, so you can afford to sacrifice weight. Here's the setup:

 Camera
 Extra memory cards
 Tripod
 Shutter release cord

And for DSLR users:
 Super telephoto lens
 Teleconverter

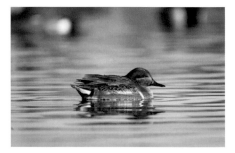

External Hard Drive

If you haven't already realized the importance of protecting your digital collection, now is the time to start thinking about it. By their nature, computers are prone to crashes and breakdowns. So it is very important that one of the first pieces of equipment you buy to complement your home computer is an external back-up hard drive. (Actually, I recommend two external hard drives.)

I am sure you know Murphy's Law: What can happen, will happen. Computers are especially prone to Murphy's Law, and back-up drives help "Murphy-proof" your digital darkroom. The idea is that, in the unfortunate event that your main computer crashes, you'll still have your entire image collection safe on another drive.

So why do I use two external hard drives? I employ a dual external hard drive system to keep a constant, safe, and reliable back-up of my computer hard drive. I store one of the drives off-site at all times to minimize the chances of losing my whole digital collection. That way, should my home-office where I keep one external drive suffer a fire, burglary, or other disaster, I am not out of business because I have another back-up of my images elsewhere. External hard drives are relatively inexpensive compared to the emotional (and in my case financial) cost of losing irreplaceable images.

Some people make their back-ups on CDs or DVDs and store them off-site. This system works great as well but if you choose to use DVDs or CDs, make sure you buy archival media and do an incremental back-up. (Incremental backups only back-up any new files you've added to the system.)

Portable Storage Device

Naturally, you can't take a desktop computer with you when you travel to the field. So if you are like me and shoot images until your card is full, you'll need some kind of portable storage device. These days, there are portable storage devices on the market that allow you copy images directly from your memory card onto the storage device. Epson and Jobo, for example, make units that are small enough to fit in a pocket yet hold 80 gigabytes of information, or more.

I carry my laptop computer and an external hard drive, and copy all of my images over to them at various breaks throughout the day to keep my memory cards freed up. When I get back home, I plug my portable hard drive into my desktop computer, download the images, do a backup, and start the image-editing process.

Printer

Today's printers, in my opinion, may be the most impressive piece in the "digital darkroom." Their ability to accurately print colors gives home users the ability to match the results that were once reserved for professional labs. When looking for a printer, try to stick with those models that use six-ink systems and sport a high dots-per-inch (dpi) ink count.

I rarely make prints at home. It isn't that I am not happy with the results, it just ends up being less time-consuming for me to send my images to a lab for printing. With high speed Internet, I can upload images to my processor's server and pick up prints from a local retailer in about an hour. Most online photo lab services will also send the prints to you in the mail, if you prefer.

Debunking Digital Myths

I once wrote a magazine column extolling the virtues of film and why film was my ultimate medium of choice. Wow! Things change. I've since embraced digital technology to the point that all of the images I take are now in digital format. Over time, I've had to upgrade my technological infrastructure by adding back-up hard drives, a monitor calibration system (to maintain accurate monitor color and help ensure that printed results match what you saw on-screen), as well as new software systems, both for image-processing and image organization and archiving.

One of the most important things I've learned is that plenty of myths swirl around the world of digital imaging. It seems like answers to common questions vary widely, and the answers often depend on whom you talk to. Here are a couple of the most common myths.

Myth: Megapixels Equal Photo Quality

If you look at camera advertisements, you'll see that many of them emphasize the number of megapixels the camera has to offer. Although megapixel count is a general way to help predict the quality of images a camera will produce, it is not the ultimate way to deter-

mine quality. The size of the imaging sensor is a significantly more important factor in determining image quality.

Both a small image sensor and a large image sensor can have an 8-megapixel rating. For example, an advanced compact digital camera may sport 8 megapixels but have a sensor size of 8.8 x 6.6 mm. On the other hand, a DSLR with the same 8-megapixel claim but a sensor size of 28.7 x 19.1 mm uses a sensor that is more than three times the size of the advanced compact digital camera in this example. Make no mistake about it - the quality of the images the two cameras produce is as different as night and day. The difference in the two cameras is that the larger sensor has larger pixels, and therefore can produce a superior image. Larger pixels equate to more color information, finer digital resolution and, in the end, higher quality images that produce higher quality enlargements at huge sizes. (Bear in mind that these size specs are for example purposes only; your camera's sensor will not necessarily match up with either of the size examples here. The important thing to keep in mind is simply that larger sensors mean better quality.)

Myth: TIFF Files are Superior to JPEGs

Since digital imagery has come into vogue, there's been a lot of debate about the quality of JPEG images when compared to TIFFs. Here's the skinny: There's really not much difference. The truth is that when you save a JPEG at the highest quality setting, the difference between that and a TIFF file is negligible.

The problem with JPEG arises when you open the image, make additional changes to it, and re-save it. Multiple saves will degrade the image quality, but some reports say that you would have to save the file upwards of three dozen times before degradation is noticeable. So if JPEGs degrade in this way, why use them? The reason is hard drive space. When comparing two files, one JPEG and one TIFF saved at the same image dimensions, a TIFF file can use up to ten times more hard drive space than its JPEG cousin. So, I recommend saving your images as JPEGs. Your hard drive will love you.

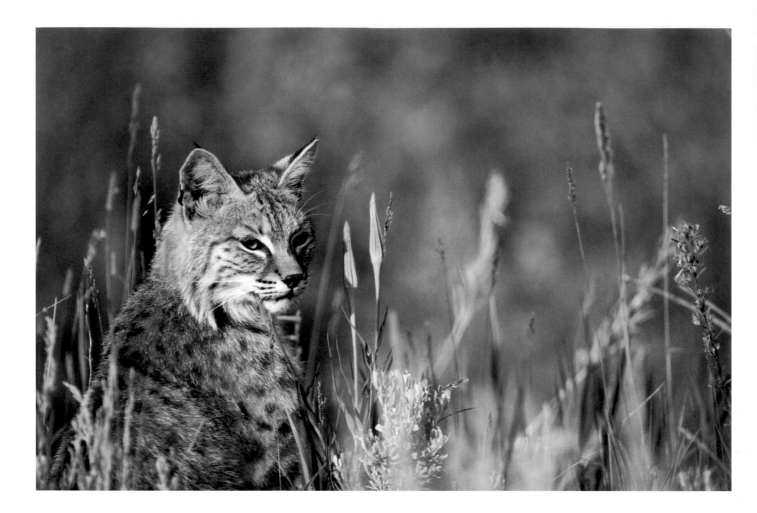

A Word About RAW Files

As you get into digital photography, you'll undoubtedly hear people talking about the image format called RAW. The RAW image format is much like a digital negative in that the image requires a bit of processing in order to make useable for applications such as printing or placement on a website. The main advantage to shooting in RAW is that it allows you more latitude to make changes to the image using image-processing software. Beginning photographers can use RAW, but it does take a bit of practice to learn how to do things like sharpen and color correct images. Additionally, RAW images add another step to your image-processing workflow and require special RAW file processing software. Once you processed a RAW file, you can then convert it to TIFF, JPEG, or your software's native image format (such as Adobe Photoshop software's PSD file). If you aren't ready for heavy image-editing and just want to shoot pictures, my advice is to use JPEGs right out of the camera.

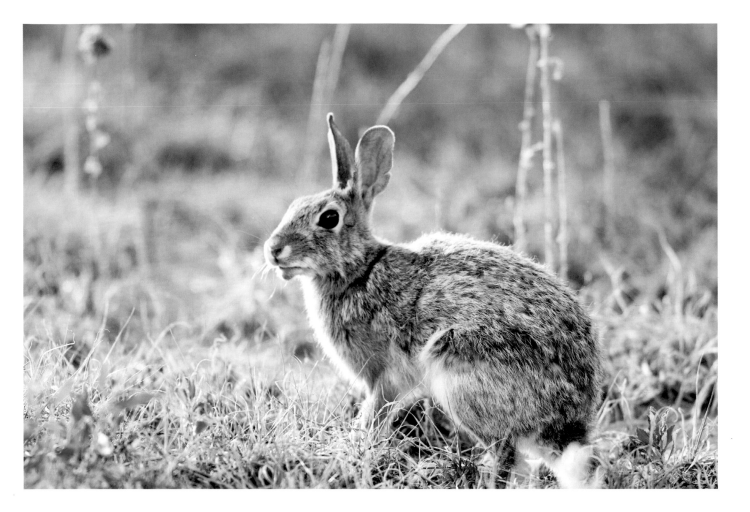

Dots-Per-Inch (DPI)

Dots-per-inch, most often referred to as DPI, is not the only measure of picture quality. When photo finishers ask you to send 300 dpi images for printing, they may not be telling you the whole story. DPI is the measure of how many dots-per-inch an image possesses. Naturally, an image with a higher DPI count will have more color information. However, perhaps as important as the DPI is the size of the image. As with image sensors, size matters.

Image size is often measured in pixels. An image that is only 500 pixels wide won't print as crisp an 11 x 14-inch (B4) enlargement as a 2000-pixel wide image would even though both images may be rated as 300 dpi. As a rule, the larger the size of an image, the larger the print you can produce. I recently made a beautiful 16 x 20-inch (A2) enlargement from a 2,500-pixel wide image. I couldn't have done that with an image much smaller than that.

In this section, you will start to learn the nuts and bolts of how your camera behaves once you press the shutter button. While technology has changed the tools, not much has changed with the ultimate goal of photography: capturing a slice of time. Therefore, it is important that you understand how aperture and shutter speed work in harmony to produce an image that is properly exposed and captures the moment just as you had envisioned. What's perhaps equally as important is how you put everything together to refine your technique.

Good photography, be it nature, wedding, portrait, or any other type, is simply a matter of consistently doing a lot of little things right. Each of the little things that go into making a great photograph influences how the end result will look. This section will help you to understand these "little things" that people often overlook.

2

Exposure, Composition, and Technique

Exposure Explained

There are a lot of books that go deep into theory about exposure, and for good reason. For the beginning photographer, it is helpful to learn as much about exposure as you can. By knowing a great deal about exposure and how light and camera settings work in harmony, you'll start producing great images almost instantly. In the end, it is all about the light. The way you translate light into results is ultimately how you'll be judged as a photographer, whether that judge is someone else or yourself. When you understand that a great photograph is as much about the light as it is the subject, you are well on your way to producing memorable images and increasing your skill level in the exciting world of nature photography.

Exposure is the amount of time that the sensitized media (in this case, the digital sensor) is exposed to light. In a digital camera, exposure is controlled by two variables: shutter speed and the aperture. Here's a good analogy: Let's say that a bucket represents your digital sensor, a stream of water represents light, and that a full bucket represents a

complete exposure. You can fill the bucket of water with a drip or with a steady stream of water, the difference being the amount of time it takes to fill the bucket. Shutter speed and aperture are the "faucets" that control the flow of water.

In nature photography, exposures can range from 1/8000 of a second to several minutes. Usually your subject dictates what kind of exposure you are trying to achieve. If you shoot landscapes at first light, then you'll need a long exposure to

29

capture a wide depth of field. With wildlife, depth of field isn't so important. Also, animals move around a lot so you'll want to use a faster shutter speed to capture the action. In all, proper exposure is a marriage of shutter speed, aperture, and ISO sensitivity (which determines how sensitively your digital sensor reacts to light for a given exposure).

Shutter Speed

Shutter speed, usually defined in fractions of a second, is the amount of time that the shutter stays open and allows light to pass through the camera to strike the digital sensor. On older cameras, each shutter speed increment allowed either twice as much or half as much light as the next setting. For example, 1/500 second allows in half as much light as 1/1000 second and twice as much light as 1/250 second. These increments are called "stops."

You'll often hear photographers talking about adding a stop of light to a photograph. All that means is that they need to slow the shutter speed by one time increment (or widen the aperture) to add light to the photograph. For example, going from 1/500 second to 1/250 second would be adding a stop of light. Most modern cameras will even let you adjust the shutter speed in third or half stops for even more exacting exposures.

The type of image you want to take usually dictates the shutter speed you'll likely use. Fast action photography calls for fast shutter speeds like 1/500 of a second, 1/1000 second, or faster. Landscapes with a wide depth of field and low-light scenes call for slower exposures like 1/30 second and slower. (See pages 32–33 for more about depth of

field.). You can also use shutter speed creatively to add a sense of motion to a scene. Choose a shutter speed that is slow enough to render a moving subject with a slight blur. (How much blur you use for creative purposes is a matter of personal taste.)

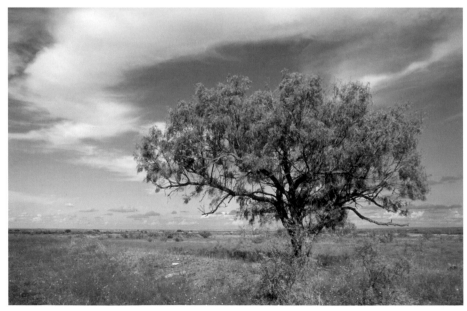

It should also be mentioned that the amount of ambient light (the existing light in a scene) influences shutter speed. On a bright sunny day, your shutter speed will be higher because of the amount of light entering the camera. Early in the morning, late in the evening, or on overcast days, there is not as much ambient light. Therefore, shutter speeds will have to be slower to correctly expose the image. The correct amount of light in a scene is known as a proper exposure. Too much light in the final image is called overexposure while not enough light, causing a dark picture, is known as underexposure.

Aperture

The aperture is an assembly inside the lens that, like the shutter, affects how much light enters the camera. Apertures consist of a diaphragm that is made up of a series of thin metal blades that work in a similar fashion to the iris in your eye. If you need more light, open the aperture up wide. If you need to limit the light, close the aperture down to a smaller opening.

The size of the aperture opening is referred to as the f/stop. F/stops are expressed by using the letter "f" and a corresponding number, such as f/5.6. Lens speed ratings are made based on their f/stop capabilities. "Fast" lenses are those that let in a

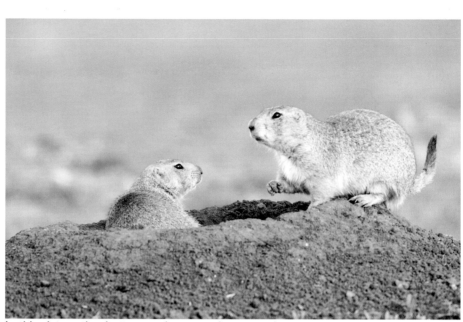

In this picture, the shutter speed was too slow to produce a correct exposure. Therefore, the colors appear washed out.

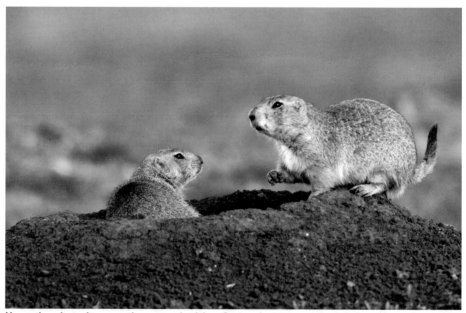

Here, the photo is correctly exposed with a faster shutter speed, and the colors are vivid and lifelike.

Demystifying Depth of Field

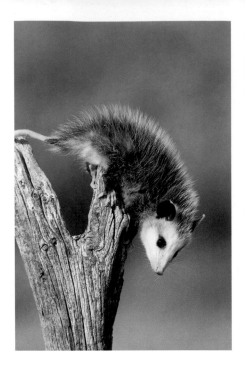

lot of light when they are opened to their widest aperture setting, usually those in the f/1.2 to f/4 range, depending on the focal length.

Aperture and shutter speed work in concert to control the amount of light reaching the digital sensor. To call the relationship between the shutter speed and aperture symbiotic would be accurate. It works like this: For every increment you open the aperture on a lens, you have to adjust the shutter speed to a higher speed to account for the increased light entering the camera. (Your camera's aperture-priority and shutter-priority settings do this automatically.)

The aperture also allows you to make refinements to the look of an image, such as how much of the image is in sharp focus, also know as the image's depth of field. As a rule, the higher the f/stop (the smaller the aperture), the greater the depth of field; conversely, the lower the f/stop (the wider the aperture), the more depth of field will be limited. Use aperture to throw the background out of focus and emphasize your subject, or to broaden the depth of the image by keeping things in sharp from foreground to background.

When I was a beginning photographer, I learned photography in large part by studying the works of others. Thinking back, one of the magazines I studied in earnest was Sports Illustrated. If you study the magazine like I did, you'll see that many of their pages feature photographs where the athlete is in sharp focus while the background reverts to a jumbling of out-of-focus shapes. Looking at those images, I knew that if I wanted to become a better photographer, I had to master the technique used to isolate a subject against an out-of-focus background. I began to experiment and try to figure out this seemingly exotic technique. What I found is that it isn't so exotic after all.

The technique I studied long ago was mastering how to control a photo's depth of field. Simply defined, depth of field is the amount of space, in front of and behind a subject, that is in sharp focus. A deep depth of field has a large amount of space that's in focus; this is useful for landscape photography. A shallow depth of field is where only a very narrow zone is in sharp focus; this is desirable when you are shooting photos of prominent subject, such as a white-tailed deer in a meadow. Shallow depth of field isolates the

subject against an out-of-focus background and is a pleasing way of shooting pictures of animals or people.

Depth of field is controlled by the lens aperture, often referred to in terms of an f/stop or f/number (see page 31). The larger the f/number, the smaller the lens opening; the smaller the f/number, the larger the lens opening. For example, an f/4 aperture is a larger opening than an f/22 aperture and will allow more light to pass through the lens.

Lens aperture works similarly to the iris in your eye. When low light conditions exist, your eye's iris opens wide to let in more light. As the light brightens, the iris closes down. A good way to illustrate this is by poking two holes in a sheet of paper, one

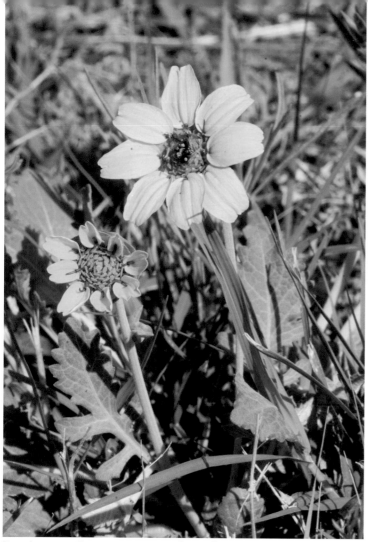

By using a small aperture opening (high f/number), you can increase the depth of field in your photo.

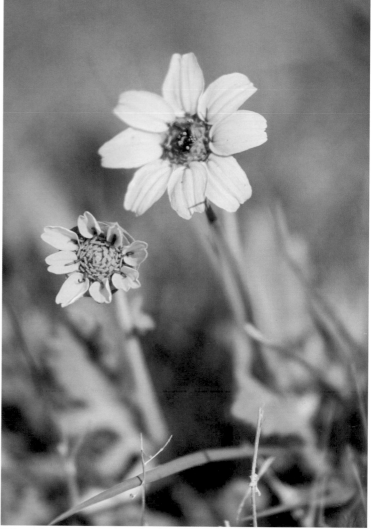

Using a large aperture opening (small f/number) will limit depth of field, throwing the background out of focus while keeping the subject sharp.

the size of the tip of your pencil and one the size of the pencil itself. Then, hold your thumb up about a foot in front of your face, close one eye, and focus on a distant object. When you move the paper over your eye, you'll notice that your thumb becomes a little more in focus as you look through the small hole and a little less in focus as you look through the larger hole.

A great way to start controlling depth of field is to set your camera to its aperture-priority mode, if it has one (often signified by the letters Av or A). In this mode, you set the aperture and the camera will set the appropriate shutter speed based on the light levels of the scene. This

allows you to confidently control depth of field while leaving shutter speed up to the camera so you can concentrate on making the picture. Sound easy? It is. Start adjusting the aperture and playing with depth of field and you'll see how easy it is to make images like a pro.

ISO Sensitivity

The ISO sensitivity setting on your digital camera controls how the sensor responds to light. Back in the day when most photographers used film, the ISO speed of film measured the same thing – the film's sensitivity to light. Ultimately, the ISO sensitivity you select determines the exposure range of your photos.

With film cameras, if you wanted to change the ISO, you had to change the film. With digital cameras, though, you can change the ISO on the fly by pressing a few buttons. The ability to change ISO settings from picture to picture makes it simple to adjust to just about any lighting situation with ease.

The higher the ISO number, the more sensitively the sensor will react to light. For example, for low light situations where you need to keep shutter speeds high, you'll want to set the ISO so the sensor is very sensitive to light. In that case bump the ISO to 800 or 1600. On bright sunny days when shooting static subjects, you may want to opt for a lower ISO like 100.

Now you may be thinking, "Why not use a high ISO all the time?" The reason is that, as the ISO goes up, the image quality goes down. Back in the film days, high ISO films meant you'd get artifacts in the image called grain. In digital images, this "grain" is called noise. While modern digital cameras perform well at higher ISO settings, noise is still a factor with which you have to contend. If you want consistently clean, crisp images, you may want to always use the lowest possible ISO.

Common Outdoor Exposure Problems

Now that you have a working grasp of what shutter speed and aperture mean and how to arrive at a base exposure, you are ready to head out and start making images. However, do yourself a favor and don't rely on your camera to make all of your decisions for you. The minute you learn how to adjust your camera and read light, your images will start to improve dramatically.

When outdoors, you have to start thinking about light and how you want the light to be portrayed. In the studio, light is carefully controlled, and in many instances, there isn't much difference in light intensity between the subject and the background. In the outdoors, however, the rules change.

In nature photography, you will often have scenes where the sun may be shining on an animal but the background is in shadow. In many cases, the camera meter will see a scene like this and expose for the shadows. The result is an animal that is overexposed but a background that looks nice. Or, you may be photographing a flower that is in shadow while the background is in the sun. If you leave everything up to the camera meter, you may have a background that is properly exposed but a subject that is dark and underexposed. So what do you do?

I always look at the scene and decide the point of the scene that I want to expose for. If a deer is in bright light, then I adjust my camera to expose for the highlights of the scene. Often, I'll take a meter

reading off of a bright blue northern sky to arrive at the full sunlight exposure. The blue sky, like the deer's hide, is a middle toned subject so the sunlight intensity on each should be the same.

If I am close enough to the subject, I may try to isolate the part of the subject I want to photograph, but that's rarely the case when shooting wildlife. Therefore, I am constantly looking for similarly toned scenes that are lit the same as my subject. For example, I may swing my camera over to a patch of well-lit grass, take an exposure reading, and replicate it on the deer once I recompose.

For static subjects like a flower, I may just move in close enough to fill the entire frame with my subject, take a meter reading, then back up and recompose, and use the meter reading I've already recorded to capture the image. Again, the key is to decide what kind of light you want to expose for and find similarly lit scenes on which to base your exposure.

As a side note, one piece of equipment I find myself using a lot is a handheld incident light meter. This meter measures the amount of light falling on a subject. If I am in full sun and my subject is in full sun then we are lit with equal intensity. I can hold the meter in the sunlight,

take a reading, and then dial the meter reading into my camera and I know I will have a properly exposed subject regardless of how dark or light the background may be.

The Histogram

In my opinion, one of the handiest features of digital cameras is their ability to graphically represent a scene's light intensity. This graphical representation is called a histogram. Learning how to read a histogram will make you a better photographer.

Histograms are pretty easy to explain. On the left side of the histogram, shadows are represented, highlights are on the right side, and midtones are in the middle. While you are learning to read light, the histogram will help you interpret what you see.

For instance, a middle-toned scene like a grassy field and blue sky in full sunlight will be expressed in the

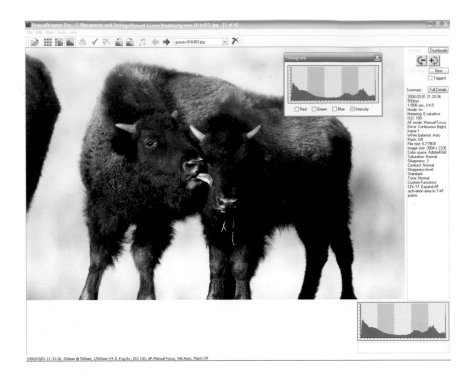

2006/03/01 21:33:36, 500mm @ 500mm, 1/500sec f/4.5, Exp:Av, ISO 100, AF:Manual Focus, WB:Auto, Flash:Off

Compose Like the Pros

As with many photographers, when I first started taking pictures, all of the details involved in shooting images mired the process. The deliberate methodology of taking pictures consumed my thoughts; I was thinking about the process too much. Golfers will tell you that thinking too much about technique messes with your mind. Instead, a golf swing should flow instinctively. Curiously, I believe the same thing applies to photography: If you think too much about taking pictures, you'll miss the proverbial forest for the trees. Instead, try mastering the basic steps of composition as a break from exposure details. Composition is just as necessary as exposure, from both a technical and an artistic standpoint. Want to start taking better photos right now? Follow these three steps:

histogram with the peaks in the middle. A snow filled scene, with lots of highlights, will spike on the right side of the histogram, while an image of a dark animal like a bison will have the bulk of the histogram's peaks on the left side. The key is understanding where colors should be represented on a histogram and then adjusting accordingly.

Let's say that you are shooting an image of a buffalo against a blue sky. The dark tones of the buffalo ought to register in the histogram along the left side while the middle toned blue areas would be represented in the middle of the histogram. Suppose I took this shot and checked my histogram and saw that most of the peaks were in the middle and on the right. Most likely, the image is overexposed.

Whenever an image is overexposed, it means you have too much light hitting the sensor. In that case, you'll need to adjust the exposure by opting for a faster shutter speed or closing down the aperture. With film, you would learn by trial and error, but with digital, that tiny graphic on the back of your camera is your on-demand tutor for achieving correct exposures. In general, the lines of the histogram should stay within the bounds of the graph. If the lines go off the graph to the left or right before reaching the bottom horizontal axis, chances are that portions of your image are under- or overexposed and you should re-shoot.

Step One: Get Close

One of the biggest mistakes that beginner photographers make is not getting close enough to their subject. Everyone who has ever taken a picture in the film days can relate

to the disappointment you feel when the film comes from the lab and a subject that was clearly visible in the viewfinder when you took the picture is just a speck on the finished photograph. To remedy this problem, get close.

You can get closer to your subject in two ways: optically and physically. Getting closer to the subject from an optical standpoint is easy to achieve. All it takes is the use of telephoto focal lengths. In photography terms, a telephoto lens is anything that magnifies normal vision. Telephoto lenses come in a variety of ranges, including telephoto zoom lenses. 200mm telephotos are the most common.

Getting physically closer is the easier and less costly alternative. Simply move your body closer to the subject. For taking pictures of a person, getting close is relatively easy to accomplish, but for shy subjects such as wildlife, you should use a telephoto lens of some kind. Get as close as you can and try to make your main subject fill most of the frame.

Step Two: Keep the Sun at Your Back

By keeping the sun at your back, natural light will more evenly illuminate your subject. Natural light is, by most accounts, far superior to any artificial light, such as electronic flashes or indoor lighting. Keeping the sun at your back is basically impossible during midday because the sun is overhead. Midday light is harsh and the sun shines straight down on the subject, lighting the top of it. Consequently, the best time to shoot photos (in terms of the quality of light) is two hours after sunrise and two hours before sunset.

During these times of optimum photographic illumination, the light takes on a softer and more golden hue that lends itself well to nature photography. Skin tones take on a

more natural appearance during the first and last couple of hours of sunlight, and colors appear richer and more natural.

Don't lock yourself into keeping the sun at your back all the time, however. Sometimes if the sun is low, your shadow will appear in the photo, causing a less desirable situation. In this case, move around the subject and try side lighting or backlighting. And of course, this rule does not apply when shooting silhouettes. You should note, however, that when shooting silhouettes, be sure not to look at the sun through the lens of a camera for more than a brief instant or you can severely damage your eye.

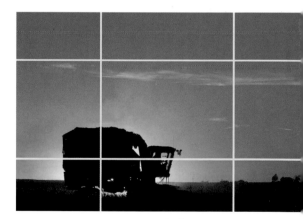

Step Three: Use the Rule of Thirds

The rule of thirds is a term that deals with photographic composition. The human brain finds photos that are composed slightly off-center more appealing than ones that

are centered. Using the rule of thirds is simple: Imagine that your viewfinder is broken up into even thirds across both the horizontal and vertical planes. Better yet, when you look through the viewfinder, imagine a tic-tac-toe grid on top of the scene you are composing. Wherever the lines intersect, place the main elements of the photo there.

For example, if you are shooting a photo of a landscape, the horizon line should run either along the lower third or along the upper third of the photo, not right in the middle. In other words, do not center your photos. Play around with the composition until you find something that is appealing to you. The same applies to vertical compositions. Many photographers find themselves locked into horizontal composition and can't see the world otherwise. Try to take a photo both in the horizontal and vertical shooting positions, remembering to use the rule of thirds, and see which one looks the best. With digital, there isn't any film to waste, so let yourself experiment and simply delete the shots that don't work out. The only way to get better is to practice. If you can master the rule of thirds, your photos will immediately look more appealing.

Photography is an intriguing hobby and a powerful tool for capturing the world around us. Today's cameras are technological marvels capable of controlling everything for the photographer. As smart as cameras are, however, their excellence is still limited to the person using them. The human factor is the elemental key in determining whether a camera takes good or bad photos. Using the three basic steps of photography I just outlined (getting close, keeping the sun at your back, and using the rule of thirds), you can go a long way in ensuring that your photos see more than the bottom of a wastebasket or your computer's trash can.

Ten Ways to Improve Your Photography

Shooting great photos, like anything else, takes a certain amount of skill as well as luck. Great equipment and sound fundamental techniques help improve your odds of getting memorable images, but aren't necessarily a panacea. Instead, in the photo game, you should be aware of nuances that help you elevate your skills to the next level.

When I first started taking pictures, getting great shots was about 90% luck and 10% skill. Now those numbers are reversed and my chances of getting great images each time I take a picture are almost 100%. Like any product you use and are happy with, the results you get from your camera should be predictable and consistent. Want to build consistency? Follow these tips.

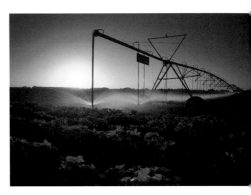

#1 – Shoot in "Sweet Light"
When shooting outdoor photographs, relegate most of your photo shoots to the first and last couple of hours of the day. Pro photographers agree that early and late light is preferred if you have a choice as to when you'll shoot photographs. The low angle of the sun evenly illuminates your subject in golden light as opposed to the harsh, flat light of midday. If you must shoot at midday, use a flash.

#2 – Plan Your Shots

If you are shooting pictures of a specific activity, such as fishing, make a plan of the kinds of images you want. Then, shoot for the plan. I put a considerable amount of time into thinking about images I should take and sometimes even sketch them on paper to visualize what I want. If you plan your shoot, you'll be surprised at how thoroughly you'll document the event.

#3 – Always Be Prepared

Whether I'm traveling down a dirt road or a state highway, I always have my camera at my side, ready for action. I've taken scores of photos (many of which have made the covers of magazines) from the cab of my pickup.

#4 – Shoot Lots of Images

Shooting pictures is like shooting a basketball. To get better, you have to practice. With photography, practice means taking many pictures, evaluating your work, and shooting some more. With digital cameras, photo feedback is instant, which substantially decreases the learning curve. Pay attention to your mistakes. And furthermore, learn what you are doing right and maximize your successes. By doing so, the quality of your work will increase.

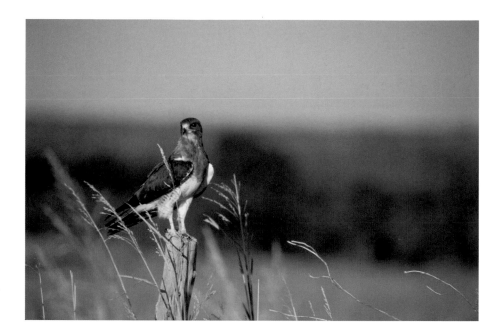

Shooting a lot of pictures also ensures that you get the photo you're after. Suppose you take a shot of your buddy on the edge of a scenic canyon, and in the only photo you shot, his eyes are closed. You blew it. Had you have taken four or five of those shots, chances are at least one of them would have been good. And again, with digital, there's no film to waste, so why not take a few shots and choose the best one?

#5 – Study the Craft

Although I guess some people may be naturally talented as photographers, most learn the old fashioned way: they pound away at it until they get good. Now, I'm not saying that you should quit your job and study photography full time. What I am saying is that you should read books, magazines, and Internet resources that deal with photography equipment and technique. The more you know, the quicker you'll close the gap between good pictures that happen haphazardly and photos that are consistently good.

#6 – Study Other People's Work

A sure-fire way to help define your own photographic style is to study the work of others. Musicians have other musicians who've influenced their style of music, and photographers are no different. My influences are photographers Wyman Meinzer, David Sams, and Grady Allen. When I first started taking pictures, I studied all kinds of pictures to learn specific lighting and composition techniques. As I began

to master the technical basics of photography, I started trying to develop an artistic vision by studying the work of prominent nature photographers. To this day, I still look at what others are doing for inspiration and ideas that will help me define my own style.

#7 – Study Your Own Work

The best troubleshooting procedure I know is to study my own work. When I take the time to look critically at my photographs, I can isolate mistakes I've made and take steps to correct them. Here's an example: A few years ago, I noticed a trend in my photos. Almost all the images I shot with a telephoto lens were a bit blurry. I knew the problem wasn't with the lenses as I had the best that the camera manufacturer offered. The problem had to be with me. So, I refined my technique by using a tripod with my big lenses. Now, virtually every image I shoot is tack sharp.

As you study your work, you may find common mistakes that you make again and again. Study the problem, check photographic resources like books or websites, and come up with a solution. You'll be glad you did.

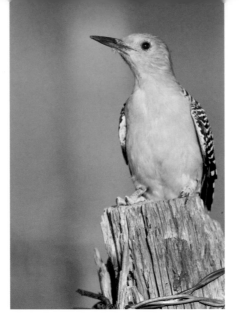

#8 – Think Carefully and Shoot Deliberately

I wish I had a chance to retake all the images I blew back when I thought the automatic setting on my camera was all I needed to take great photos. I can trace back, nearly to the day, to when my photos started to improve – when I quit letting the camera do the thinking for me.

One prominent photographer I spoke with estimated that 80% of the exposure settings that today's modern cameras recommend are wrong. Eighty percent! That means if you let your camera do the thinking for you, 80% of your images could be better. Once I started setting my camera manually, my photos instantly became better. Do yourself a favor. Learn how light and shadows affect your camera's meter and adjust accordingly.

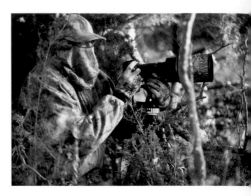

#9 – Dress Seasonally

When shooting wildlife pictures, it helps to remain out of sight as much as possible. Therefore, I have several sets of camouflage clothing patterns so I can dress according to the season. Throughout the year, as the seasons change, I try to match the color of the clothes I'm wearing as closely as I can to the terrain. Some might argue that "camo is camo," but for a shot of a wild, trophy-class whitetail, I'm not willing to take a chance.

#10 – Be There

When I talk to people about what it takes to shoot great photographs, I remind them that sometimes it takes getting up at 3:00 am and driving a hundred miles to be in place before the sun comes up. Half the battle of taking great photos is being there in the first place. Simply put, all the technical expertise and artistic vision in the world is no good in the digital nature photography arena if you stay in the house all the time.

Rock Steady – Take Sharp Pictures without a Tripod

Five steps towards the mule deer, and already I know I can make the stalk. The problem is that I have about a hundred more steps to go through tall grass and brush. The mule deer is on the move, and I have to move quickly if I want to try to get a shot of him before he melts into the badlands.

When I slip from my truck, I opt for a 300mm lens; it's a heavy one. I decide that a tripod is too cumbersome so I opt to hold the heavy lens in my hand. I do not handhold such a big lens often, but when I do, I am confident that if I use the proper technique, I can achieve good results under the toughest conditions.

Proper Camera Handling

In my opinion, one can hold a camera two ways: the right way and the wrong way. I often see amateur photographers gripping each side of their camera as they pull it to their face to take a picture or I will see them holding the camera with their right hand and gripping the side of the lens with their left hand. For maximum steadiness, neither way is the correct way to ensure sharp pictures.

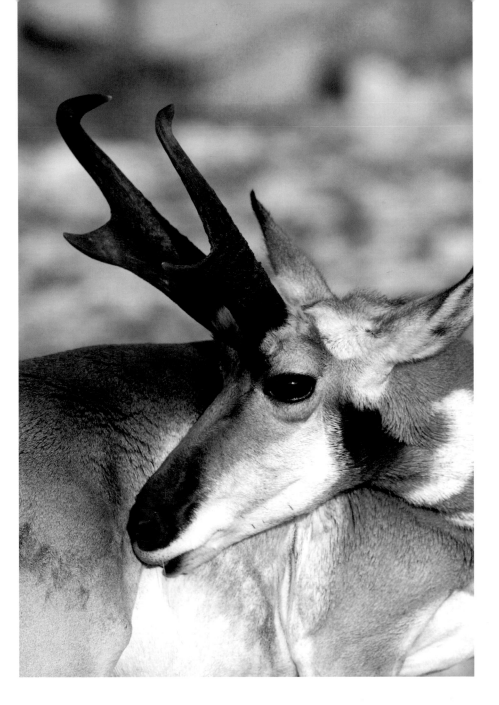

Camera shake is one of the main causes of blurred images. Often, people think they have a bad lens or that the digital processor made an error. However, you can attribute many blurry pictures to poor camera handling technique. The next time you are shooting pictures, try the method pros have perfected.

With just a slight shift in camera handling, your technique becomes more sound and your pictures become sharper and clearer.

Use what Nature Provides

When I am in the field and cannot use a tripod, I often find a natural way to steady myself. When setting up on the ground, I like to find a tree that I can lean against to steady my upper body, which in turn steadies the camera. A limb to prop the lens on also works well. Where available, big rocks also make great camera supports. The trick to using nature to improve your camera's steadiness is to be creative.

Here is how it works: Grasp the camera with your right hand as you normally would. Place the bottom of the camera on the base of your left palm and rest the lens on the tips of your fingers. Whether you use manual focus or autofocus, this technique will work well.

If you shoot with a bigger lens, move your hand out toward the end of the lens until the camera feels balanced in your hands. While holding the camera, keep your elbows against your ribs and one foot slightly in front of the other. Keeping your elbows tucked in minimizes upper body movement, while staggering your feet steadies your lower body. The more compact you can keep your body, the steadier you become. Of course, standing is the least steady way to hold a camera; kneeling and prone (lying with your stomach against the ground) are the steadiest. When you are ready to take a picture, depress the shutter button slowly and steadily – don't jab at it. The key is to be deliberate in your moves and take your time.

Technology to the Rescue

Over the past few years, some camera manufacturers have introduced technology that makes handholding even easier: image stabilization lenses and anti-shake camera bodies. The lenses come equipped with internal stabilization technology that counteracts the movement caused by a shaky camera handler. As a result, big lenses can be handheld at slower shutter speeds resulting in sharper images.

Anti-shake technology works the same way as the internal lens stabilization except that the effects of camera shake are countered in the camera and not in the lens. Whichever technology you may choose to employ, both anti-shake and internal lens image stabilization are great tools for helping you to consistently achieve impressive images.

The Bottom Line

The bottom line is that, whenever possible, you should use a tripod, especially with long telephoto lenses. I can tell you from personal experience that when I started using a tripod religiously, my images became much better. A good, sturdy tripod eliminates nearly all camera shake and improves your telephoto and slow shutter speed images dramatically.

At times, however, we all know that a tripod is too cumbersome or too slow to use. In that case, I always fall back on the methods I've described here. Practice these techniques, master them, and soon you will start to see dramatic improvements in your images as you capture the grandeur of the wild outdoors.

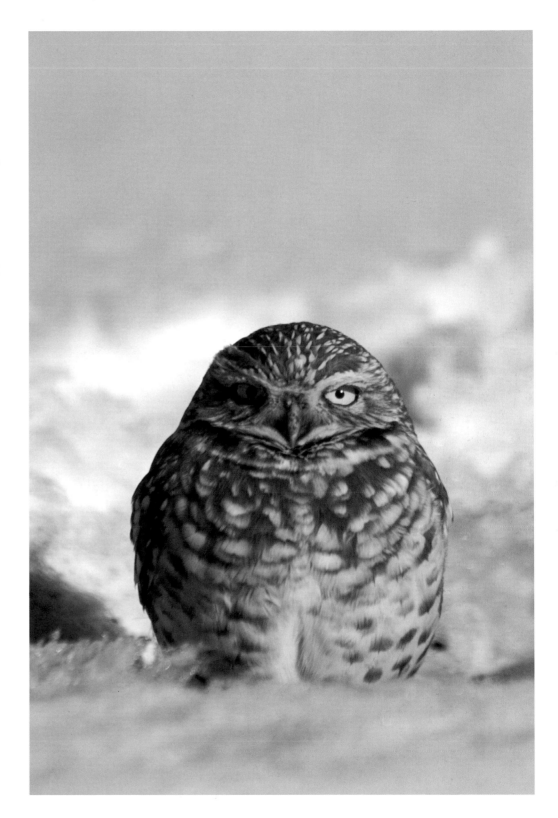

In this chapter, we will explore how to effectively use your equipment to the fullest while you are in the field. As I said earlier, great nature photographs are a result of doing little things right over and over again until your results become predictable. Before we delve further into hands-on lessons, however, there are a few more items I'd like to recommend to you beyond the basics that we discussed in chapter one.

3

Lessons in the Field

Equipment Extras

Aside from the equipment I've already recommended, there are a few additional (and relatively inexpensive) accessories you can pick up that will also help you in your effort to take great digital nature images.

Using a reflector allows you to bounce light onto a subject to fill in shadows. The photo above has no reflected light, while the image below was taken using a reflector.

Reflector

If you are interested in taking pictures of flowers, macro photography, or photographing people in the outdoors, reflectors are an indispensable extra that you should look into acquiring. Reflectors do just what their name implies: They reflect light where you want it. Suppose you are taking a picture of a flower and a big shadow looms over it. Place a reflector close by and you can bounce light onto the subject. Or, suppose your background is in deep shade and the foreground is not and you want to balance out the light; you can use a reflector to bounce light away from the bright foreground and reduce the amount of contrast in the scene.

Reflectors also work well on people when the sun is at their back, or they're wearing a hat and you want to provide a little fill light to shadow areas of the face. Although a flash can do essentially the same thing, aiming it exactly where you want may require a flash cord. Plus, a reflector never needs batteries.

Lots of manufacturers and retailers make their own reflectors, but you can go to your local discount corner store and pick up a car windshield reflector that will do the trick. Yep, that's right; the reflectors made to be placed in your car's windshield

to help deflect heat and keep the inside comfortable also work great as photographic reflectors. Silver or gold colors work best for natural looking light, but for a creative touch you may want to try different colors. Reflectors (both those for car windshields and those designed for use with photography) are lightweight and fold up easily for maximum portability, so they're easy to bring along on a day of shooting.

Flash Cord

A flash cord is a cable that connects your flash to the camera and enables you to use the flash free-handedly. Good flash cords allow the flash and camera to communicate with one another and retain full metering capabilities, so that is something to check for when making your purchase. Taking the flash

off your camera gives you much more versatile lighting options. With the flash on a cord, you can creatively add light and shadow exactly where you want it on your subject.

by far the best option. But for those times when a tripod is impractical, a monopod is still better than hand-holding the camera, particularly if you have a heavy a telephoto lens.

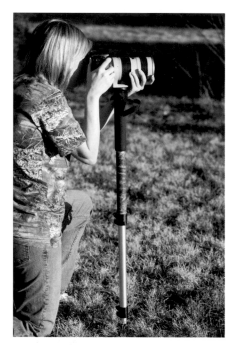

Monopod

Monopods are a great tripod substitute when you are on the move. A monopod is like a single leg on a tripod. Instead of having to take the time to set up a tripod, all a monopod needs is a firm base upon which to set the single leg. For dynamic subjects like wildlife, a monopod may be a logical choice for supporting your camera. Be advised though, that a monopod isn't nearly as steady as a tripod. For the sharpest photos, a tripod is

Beanbag Rest

One of my favorite photo accessories is my beanbag camera rest. I use it as another means of support for my telephoto lenses. For example, when I am cruising around a wildlife refuge or private land in my pickup and I spot something I want to photograph, I place the beanbag on my truck's open window and lay the camera on the bag for a firm rest. Beanbag rests also work great on the ground. I simply place the beanbag on the ground and lay my camera and telephoto lens across it. One handy feature of some beanbag rests is that they allow you to fill them with the material of your choice. I use feed corn to fill mine. That way, if I need to put out a bit of bait to keep wildlife close, I always have some on hand.

Flash Extender

One last cool field accessory is a flash extender. Flash extenders consist of a bit of plastic and a Fresnel lens (a lightweight lens with a large aperture and a short focal length) that concentrates the flash beam. Typically, a camera flash is made for subjects that are close. In fact, most flash units don't work very well beyond thirty feet or so. The flash extender helps project the flash and extend its range. Instead of only using flash with wide-angle or normal lenses, you can now use it with your telephoto lenses and help bring out color and fill shadows on wildlife that is one hundred or so feet away.

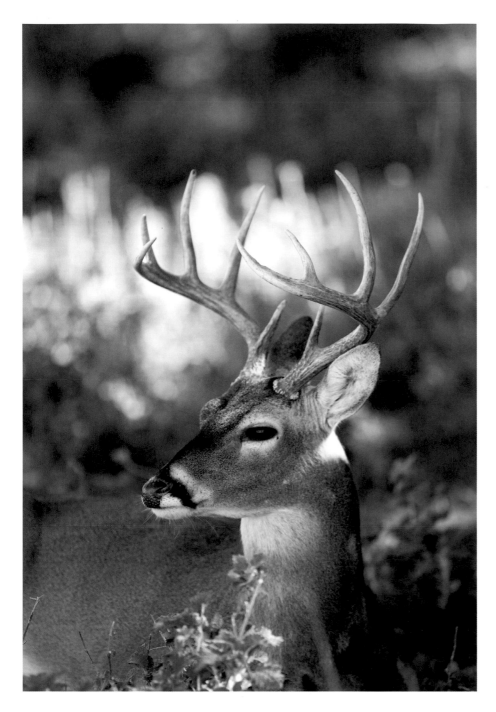

gear I carry. The cool thing about these items is that they'll all fit easily into your photo backpack, or just as easily in the pocket of a shirt or a fanny pack. Furthermore, all the items mentioned are easy to find and are inexpensive. And I'm glad they are inexpensive; I keep misplacing my blower brush.

#1 - Blower Brush

The blower brush is one of my most important tools. It's great for dusting debris from the lens and camera body. Keeping the lens free from debris will save you from having to edit out dust spots from your images later during the image-processing stage.

#2 - Film Canisters

Although for most of us film is a thing of the past, one seemingly trivial relic of the days of film is still useful: the plastic film canister. (Of course, any similarly sized container will also do the trick.) The cool thing about these canisters is that they are utilitarian. You can carry small batteries, camera accessories such as a hot-shoe cover, or just

Five In-the-Field "Must Haves"

As I sift through my photo equipment looking for just the right combination of gear for an upcoming trip, I am careful to pack all the essentials. Of course I'll pack some cameras, lenses, a tripod, and my memory cards, but that's not all. In my pack go five essential items that are nearly as important as the thousands of dollars worth of camera

about any other small item you can think of. And, if you really want to go the extra mile to capture great wildlife images, look into getting cover scents from your local hunting and fishing store. You can then put cotton balls saturated with your cover scent into the film canister. When you find a good place to set up out in the field, place the open canisters around your position to mask your scent. When you are finished, collect and cap the canisters and use them later.

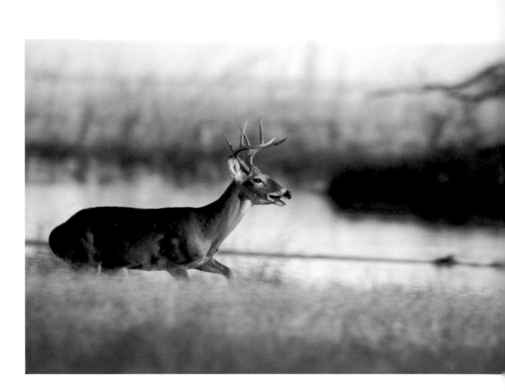

#3 – Brush Clippers

Brush clippers are money well spent for the nature photographer. Once you've found the place from which you'll photograph, use the brush clippers to trim a limb or two out of your way and cut some brush to pile around your location. I use EZ-Kut brush cutters (www.ez-kut.us). These are a ratcheting type of cutters that have replaceable blades and will cut through limbs over an inch in diameter.

#4 – Sealable Plastic Bags

When photographing outdoors, controlling dust should be one of your main objectives. Dust can harm digital sensors and tends to work its way into the crevices of moving camera parts. Therefore, when I'm in the field, I carry gallon-sized sealable plastic bags. They wad up and fit easily into my pocket or backpack. I use them to store my memory cards and card holder, and if rain threatens, I put my cameras and lenses in the bags for waterproofing.

#5 – The Squeaker Call

One of the smallest and most useful pieces of equipment you can have in your bag is a small varmint squeaker call. All it takes to work this call is a squeeze between the fingers. The call works great to get the attention of wildlife so that they have that "alert" look when you snap their picture. I once took some photos of a badger that would have continued past me had I not gotten his attention by using the squeaker call.

Using Flash Outdoors

There was a time when I first got involved in nature photography that I didn't own a flash. Like many, I thought the only place to use a flash was indoors when you needed to produce light to make an acceptable photo. A few years and thousands of images later, I am happy to say that I learned I was wrong – dead wrong.

I discovered that flash isn't just for indoor or nighttime photography. Flashes do have a place in a nature photographer's gear bag. Using a flash extends my shooting day by providing me a high quality light source even around the noon hour when the light is flat and harsh. Therefore, every time I go into the field, a flash is one of the first things I put in my bag.

Making Colors Pop

A flash, whether built into your camera or attached to the top via the hot shoe, is an indispensable tool in making the colors in an image come to life. During the morning and evening, light flows onto your subject in a horizontal line, thus illuminating your subject well. As the sun climbs higher, however, the light's direction is more vertical. As such, the light is harsh and the shadows fall straight down.

By using flash outdoors, you can add a punch of color to your images. This is praticularly useful when your subject is in heavy shadow.

So, for example, when someone is wearing a cap, the brim casts dark shadows over their eyes and makes the image less desirable. How can you fix this problem? Easy—turn on your flash. During midday when the light and shadows are harshest, a flash adds fill light and definition to shadow areas. The result is that colors come to life.

The trick to using flash is understanding its capabilities and limitations. First off, flash units have distance limitations, and the farther the subject is from the flash, the more the light falls off. Therefore, make sure that you are within 20 feet of your subject when you plan on bathing it in light from your electronic flash. Secondly, if your subject is close enough and you are able to control the output of your flash unit, dial the power down to 1/2 or 1/4 power. The key to successfully using fill-flash to eliminate midday shadows is to add just enough light to soften the shadows and not so much light that you whitewash the subject.

Another interesting way to use flash is to bathe backlit subjects with light. Here's something to try: Set up a shot as if you were shooting a silhouette. In other words, place your subject directly against the sun. If you shoot normally, the sky will silhouette the subject, which

will be cast in shadow. Now, turn on the flash. What you'll get is the subject properly exposed with all the details in place framed nicely against the bright sky background. This effect is especially striking at sunset or sunrise.

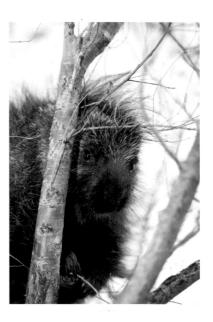

Freezing Action

Flash is great for freezing action. Let's say that the light is low and you want to shoot a photo of a bug on a flower. There's enough light for the colors in the image to appear okay, but turn on the flash and you will ensure that, whether you or your subject is moving, you will freeze the action.

Blurring Action

Although flashes can freeze action, they are also great for blurring action to add a creative twist to

your image. Many digital cameras have a feature called rear curtain sync. Check your camera manual to see if your camera has this feature. When you learn to master the rear curtain sync, your flash pictures will take on a life of their own.

Normally, a camera fires the flash just as the shutter opens, when the shutter button is pushed. If you are photographing a fast moving subject with a relatively slow shutter speed – say 1/60 of a second or slower – then the subject is frozen with slight blur. The problem with this, however, is that if the subject is moving from left to right in the frame, the subject is frozen on the left as the flash fires and the blur of the continued motion appears on the right, in front of the subject. Therefore, it gives the appearance that the subject is moving backwards.

To fix this, use rear curtain sync. Rear curtain sync works like this: When you press the shutter button, the shutter opens and begins to record the image. Just before it closes, the flash fires. The result is that the blur falls to the left of a subject moving to the right in the frame and makes the motion appear more natural. This is a fun and creative way to shoot pictures of moving subjects, and I find it works best when you set your shutter speed at about 1/15 of a second.

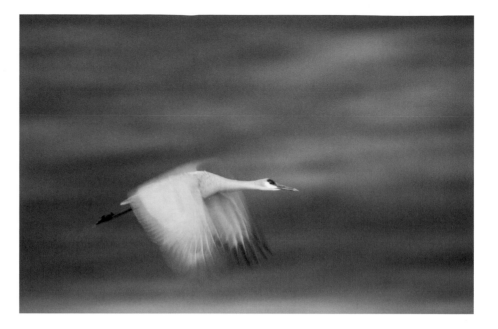

Flash on the Water

Less than two minutes into the boat ride, I know this day will be special. Speeding across the skinny Matagorda Bay, my guide expertly steers his skiff through the shoal grass flats. Upon rounding a bend that cuts through one of the bay's many inland islands, we spot something running frantically through the water. Instinctively, Scott guides his boat toward the commotion and we see that it's a coyote. Drenched with saltwater, the coyote is trying to make it back to the mainland after a night of hunting on one of the islands. Scott slows the boat and creeps up next to the coyote as it stares back at us.

Although early, the sun is already bright. I must remember all the rules of shooting photos on the water and take my time to capture this rare moment.

Rules, you say? Yep. When shooting photos on the water, a few special rules do apply. So in order to ratchet up the quality of your on-the-water photos, take heed.

The first thing you should understand about shooting photos on the water is liquid's high degree of reflectivity. At first and last light, water isn't all that reflective, but during midday, the water becomes like a mirror, reflecting light rays back toward the sky. The more light the water reflects, the harder it becomes for your camera to predict an accurate on-the-water exposure. The reason for this is that the camera tries to expose for the bright water. The result is a camera that has properly exposed for the reflective water and a subject that goes dark (much like you'd see in a silhouette photo, but minus the brilliant colors).

With that in mind, you must use your head and outsmart your camera. If your camera has adjustable controls, you can simply dial in the correct exposure by using the tried-and-true "sunny-16" rule. The sunny-16 rule says that, in bright sunlight, a camera's shutter speed should be set to correspond with the ISO you're using while the aperture is set at f/16. For example, if you are shooting at ISO 100, set your shutter speed to the closest reciprocal number, which in traditional shutter speed breakdowns would be 1/125, but many modern digital cameras have an intermediary 1/100 setting. Then set the lens aperture to f/16.

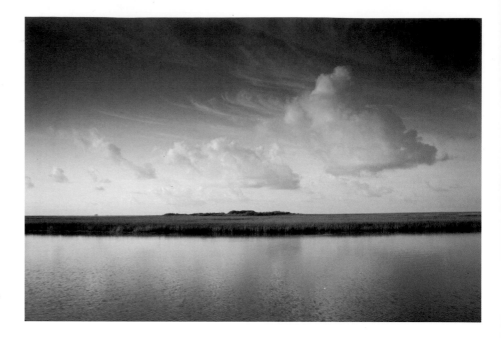

Another way to offset bright reflected light from the water's surface is to use a flash to ensure that your subject is well-lit. In bright sunlight, most flashes won't go off automatically, but most cameras allow you to override the auto flash function and use the flash when you want it. For those of you that have a built-in flash, there is often a flash button near the flash itself that will pop up the flash for use whether or not the camera meter deems it necessary. Check your camera manual for details.

Just a touch of flash adds color and depth to your subject regardless of how brightly the sun reflects off the water, so it may be something

that you use often in certain settings. Be aware that flash uses up camera batteries faster than other camera functions do. It's always a good idea to have an extra battery or batteries on hand.

Creative Shutter Speeds

When the bucks ran by, I panned my camera and squeezed the shutter to fire off a few frames. My buddy, who was taking pictures as well, noticed how slow the shutter claps seemed.

"Why was your shutter speed so slow?" he asked. "Did you not have the camera set correctly?"

"It is set right," I replied. "I meant to use a slow shutter speed."

"Won't your pictures be blurry?" he quizzed.

"Exactly," I retorted.

He stared curiously at me. At that point I explained that if he wanted to get creative with his photos, he should try manipulating the camera's shutter speed.

By manipulating the shutter speed, you can freeze or blur action scenes based on your creative whims. Remember, shutter speed is the amount of time the shutter opens to expose the sensor to the light entering through the lens. Shutter speed is expressed in a fraction of a second, but most cameras display a whole number. For example, if your camera says the shutter speed is 250, what that really means is the

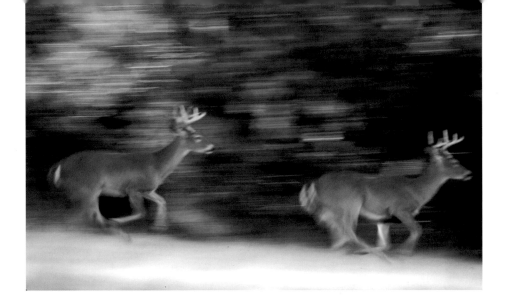

shutter will be open for 1/250 of a second. When the shutter speed is set in concert with the lens aperture, a perfectly exposed image results (see pages 29–32 for more information).

Most advanced compact digital cameras and DSLR cameras have a shutter-priority setting. This setting is an easy way to achieve a fast or slow shutter speed without having to worry about quickly changing light conditions. With shutter priority, you tell the camera what shutter speed you'd like and the camera automatically sets the aperture. (Check your camera manual for details.)

Fast Shutter Speeds

Fast shutter speeds are used to freeze action. Let's say that you want to shoot a picture of your dog running through the brush and you want it tack sharp with no blurring. In that case, a shutter speed of 1/250 of a second or faster is required. In order to get really fast shutter speeds under just about any lighting condition, you can either open the aperture to its widest available setting or raise the ISO setting on your camera to ISO 400 or higher.

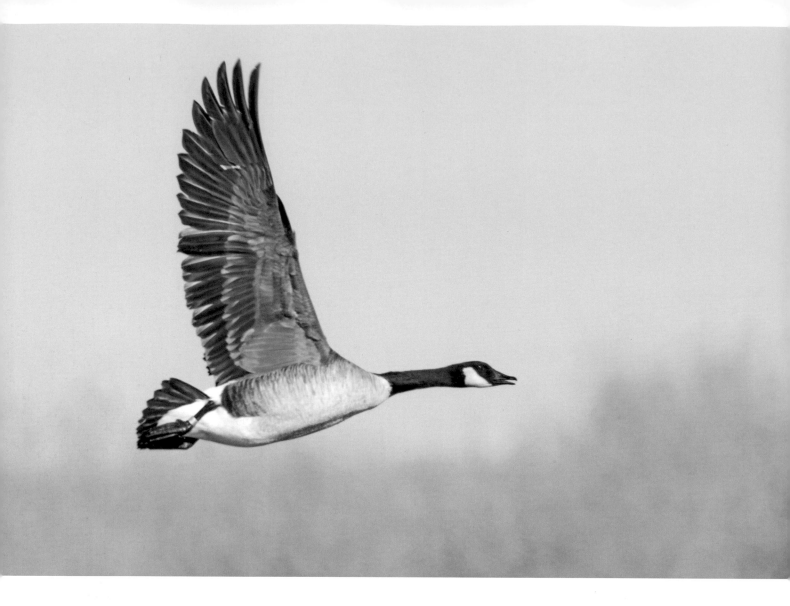

Slow Shutter Speeds

Using slow shutter speeds for action sequences is subject to artistic interpretation. Some people like the blurred effects of capturing motion with a slow shutter speed and some don't. Personally, I like blurred motion.

The trick to blurring motion is a combination of two techniques. The first is a slow shutter speed from between 1/15 and 1/125 of a second. This speed will effectively blur most fast moving objects like a running deer or a moving truck. The second technique is learning to pan with your camera. Panning is a technique where you track your subject as it moves parallel to your position. As you follow the object with your camera, you fire the shutter when the subject is composed the way you want.

Using slow shutter speeds to blur action takes a little practice but is a technique that's easily mastered. You can practice panning and shooting on kids, pets, or passing cars. Experiment with different shutter speeds and see which speed works best for you.

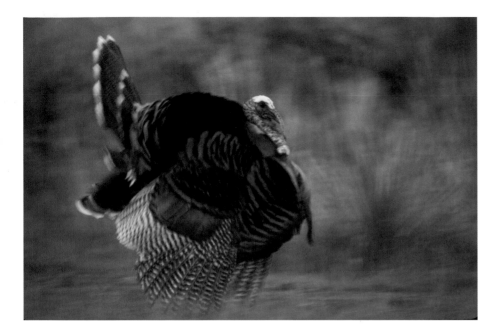

Nature Photography Quick Tips

In my approach to nature photography, I tend to be simplistic. I honestly think that many things can be accomplished well by doing a few simple things. For each of the following types of nature photography, there are a few minor details that will improve your results dramatically. The first step is mastering the basic rules of photography we've discussed thus far, and then you can combine those skills with the following tips to capture images your friends will envy.

Landscapes

• **Design elements –** In landscape photography, design elements matter. If you study great landscape photographers, you'll see that they are experts in the use of light and landscape elements. If you boil their techniques down to a few simple parts, you will soon see that great landscape images are achievable.

• **The rule of thirds –** Use the rule of thirds religiously (see pages 37–38). By using this composition rule, you have a starting point for all of your photographs. Try to keep the horizon at the top third of the frame or the bottom third depending on the image you are trying to achieve.

• **Timing –** Another important tip is to shoot early and late in the day. The first and last few minutes of sunlight each day are magical. Make sure you are in the field to take advantage of the great light.

• **Perspective –** When you are shooting landscapes, you'll often use a wide-angle lens. While wide angles take in a lot of territory, they are also notorious for showcasing a lot of nothingness in a landscape photograph. In order to preserve a sense of perspective in your image, pick an interesting object to appear in the foreground. The object can be a cactus, a rock, or some other interesting subject. The key is to place it in the foreground while adhering to the ever-important rule of thirds.

• **Horizons –** Keep the horizon level. When shooting at wide angles, it is easy to get horizons that are tilted. Before you release the shutter, check the horizon and make sure it's level. If you are still having trouble, buy a bubble level that fits in your camera's hot shoe to assist.

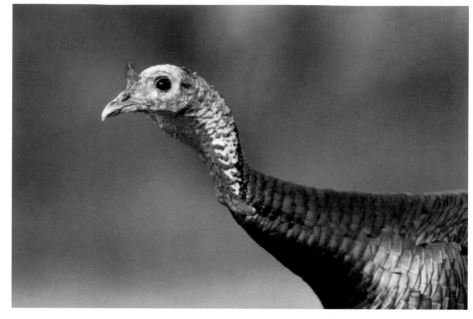

Wildlife

Wildlife, because of its inherent nature, is among the most challenging subjects you can shoot. However, when you get a great picture of a wildlife species, it will be one of your most rewarding images because of the effort it took to capture it. Therefore, when an opportunity to get the picture of a lifetime comes along, be sure to make the most of it.

• **Get close** – The closer you can get to the wildlife you're trying to capture, the better chance you have of getting a great image.

• **Focus on the eye** – Focus on the eye. You may be close to your subject and the angle of the sun may illuminate it with some of the best light you've ever seen, but if the eye is out of focus, the image is ruined. Always focus on the eye. When someone looks at your image, they will instinctively focus to the animal's eye first. Therefore, focus once, check it, and then refocus if need be. And, the beauty of shooting digital is that you can take shots along the way as you check your focus to ensure that you've captured what you want to.

• **Subject angle** – When shooting the entire body, try to get the animal broadside or quartering towards you. Quartering away or pictures of animals walking away simply aren't as powerful.

• **Shoot from eye level** – Wildlife images look best if you are on the animal's eye level. That means that for ducks in a neighborhood park, get "down and dirty" and lie prone to take the pictures.

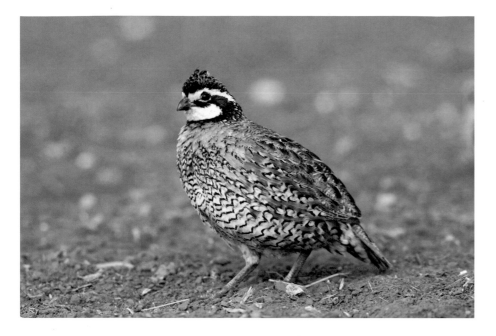

Macro

With macro photography, you'll be able to get some interesting images that people aren't used to seeing. Flowers become interesting studies as you explore its individual parts with your lens, and bugs, however turned off by them you may be, become fascinating as you explore their world with your camera.

• **Maximize depth of field –** When you are using a macro lens, the plane of focus is tiny. Bugs move, wind blows flowers around, and your subject can be in and out of focus in an instant even though your camera never moved. So, to keep more of your photos in focus, use an f/stop of at least f/8 but preferably f/11 or f/16.

• **Use flash or a high ISO –** When shooting at small apertures like f/16, your shutter speed may be too slow to freeze any of the subject's movements. You have two choices, either turn on the flash or bump the camera to a high ISO like 800 or 1000.

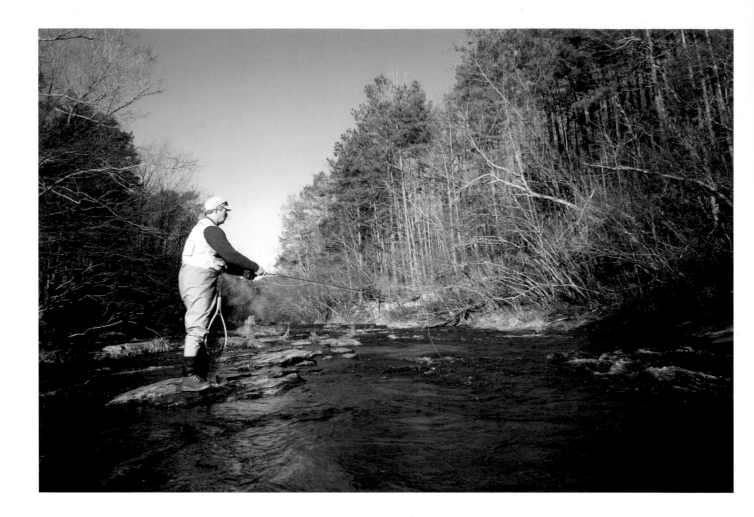

People in the Outdoors

I like to go fishing, and when I do, you can bet that I am going to take pictures of other people fishing or people holding the fish they caught. There are a few things I like to keep in mind when shooting pictures of people outdoors.

• **Colorful clothing** – Pictures of people in bright colors will make your images look brighter and livelier. If you know the people you will be photographing and have the opportunity to mention it to them before the shoot, suggest that they wear colorful clothes and not drab khaki colors and earth tones.

• **Activity** – Take pictures of people doing something. People standing still smiling for the camera is nice, but let's face it, it's been done a million times. Being outdoors is all about action and activity so keep that in mind when shooting people pictures.

• **Play with shutter speed** – Take pictures of someone casting a fishing pole or riding their bike using a slow shutter speed and panning. The key is taking interesting and believable pictures of active people doing active things.

• **Remember the eyes** – As with wildlife, make sure you focus on the eyes. Many people, however, wear caps, so you may need to turn on your flash or use a reflector to bounce a little light and fill the shadows.

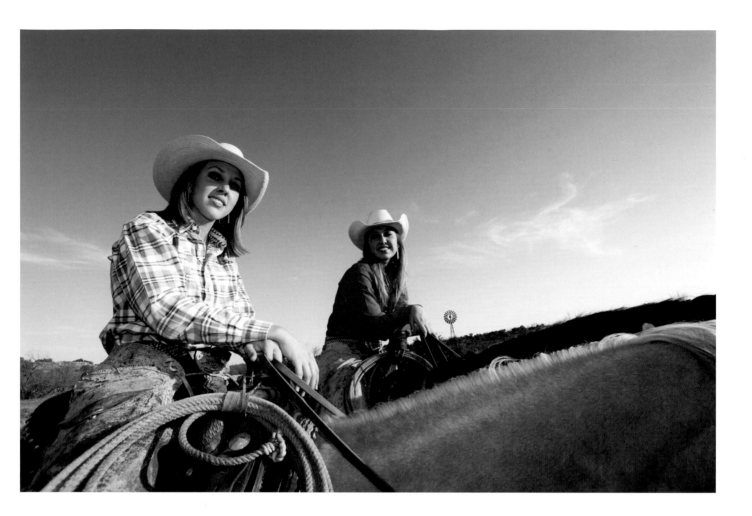

• **Try new angles** – The cool thing about digital photography is that you can experiment. When shooting people pictures, mix things up a bit. Get low and shoot up at them, get high and shoot down, get close, back up—don't be afraid to try something different.

Practice

This is perhaps the best tip I can offer: The more pictures you shoot, the better you'll get. It is as simple as that. As you practice, you are apt to try new techniques as your confidence grows. And as you try new techniques, you'll undoubtedly develop your own creative vision.

To me, nature photography means more than just flowers, animals, and landscapes. It is also very much about how people fit in, be it in the pictures themselves or simply in the relationships that allow you access to great picture taking. In this section, I will show you how to maximize your opportunities for shooting on both public and private lands, no matter what your subject is.

4

Working with People, Places, and Animals

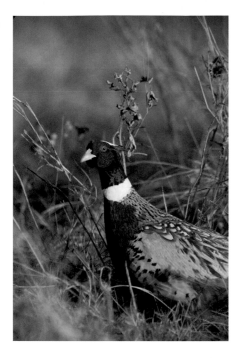

Finding Wildlife

If one of your goals for nature photography is to take great wildlife pictures, this section if for you. As much as I'd like to say that this is the easy part of digital nature photography, it isn't. Sometimes finding wildlife is easier than at other times, and just because you see something doesn't necessarily mean you can get a great picture of it. Everything has to come together just right; the light has to be warm, directional, and at your back, and you have to be close enough to the animal to get decent pictures. For all these challenges, however, wildlife pictures are very doable.

Wildlife photography is a very rewarding style of photography. In fact, of all types of nature photography, shooting pictures of wild animals—although surely the most challenging—is my favorite thing to do. When you get a great wildlife picture, nothing is more satisfying than your sense of accomplishment because you realize the work you put into the image. My best images don't happen haphazardly. For almost all my wildlife photos, I develop a plan and stick to it. Does it work? Yes, most of the time it does. I may not always get pictures of what I went after, but I almost always get pictures of something interesting.

To take great wildlife pictures, you need work towards being fairly adept at understanding both wildlife and photography. There are a few things you can do to increase your odds with wild animals. Primary among them is to become a student of your subject. I study whatever it is I want to take pictures of; I study as much as I can both in the field and in books. I try to learn about the animal so I can predict its movements and understand its behaviors. I want to know what it eats, when it eats, at what time of day it is the most active, how it moves from bedding to feeding areas and back, its breeding season, and every other little fact I can discover. Once I know its habits, I have increased my odds of seeing the animal and possibly getting an image of it. Then, I try to proof my information in the field by scouting.

When I scout animals, the most important piece of gear I have at that point is a pair of binoculars. For example, when I watch ducks, I try to see from a distance where they are congregating and where they are flying to and from. I also try to make note of pertinent activity such as whether they are feeding or resting. I then make note of the wind direction, because from my study of the ducks, I know they take off and land into the wind. Scouting is perhaps the most effective means I have for getting close to wildlife. Most wildlife species are notoriously predictable, and if you can learn how they are moving, you'll exponentially increase your odds of getting great shots.

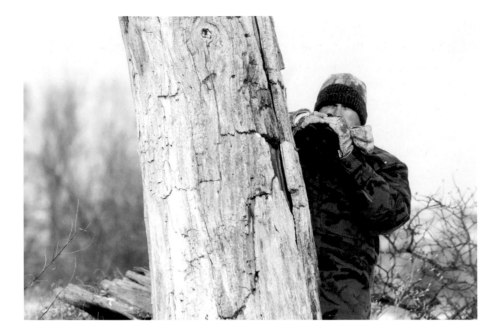

After I've gathered all the information I can, I plan an approach. Naturally, if I have shrubs or other natural vegetative cover nearby, I move behind it to remain hidden as I approach. If I don't have cover, I usually wait until the next morning and sneak in fully camouflaged under the cover of darkness. (See pages 69-73 for information about camouflage and building a field blind.)

Don't be too daunted by this approach. It is a thorough system designed to maximize both your time in the field and your photo opportunities. I do it time and again and the strategies are extremely effective. You can customize the approach for different wildlife species in different settings—even in your own backyard.

Backyard Photography

You don't have to travel far to take great pictures. You can get good shots right out of your back door. Backyard photography can open your eyes to a world of subjects just a few feet from your living room. I have taken many memorable images in my backyard, and you can, too, with very little effort. Best of all, your backyard provides a constant

source of subjects so you can hone your skills before heading off on a more involved photo excursion. Ready to get started? Here are a few things to think about:

• **Think about your landscaping –** When I bought my new house a few years ago, one of the first things I did was transform my yard from a traditional green lawn to a wild landscape. I planted native plants and some shrubs in an attempt to attract wildlife like birds and bugs, and it worked! I planted sunflowers that would drop seeds onto my lawn and provide winter food for wildlife and created pockets of cover in which small birds could hide.

• **Don't forget to feed the birds –** Song birds are easily attracted by birdseed. I try to keep birdseed out all year, but I make sure I keep it out in the winter. Cold days are especially productive for backyard bird photography because small birds need to eat a lot of seeds to maintain their energy when it's cold outside.

• **Create landing space –** I place dead limbs by my feeders so that birds have a natural place to alight. That way, when you shoot a picture, it won't look like it was taken in your backyard.

• **Be aware of the background –** Out-of-focus backgrounds look great when they are far away from the feeder and are of uniform color. Place your feeders in line with this kind of background for pleasing out-of-focus areas in your images.

Taking Pictures at the Zoo

Zoos, especially modern ones, make great places to shoot wildlife images and practice your technique. Modern zoos place animals in enclosures that mimic their native habitat. Therefore, you can get great images at zoos that look like they were taken on location in the creature's natural surroundings. Just keep an eye on the background as you shoot to make sure that no distracting elements—like signs or people—find their way into the picture. If the animals you are shooting are behind glass, you'll need to use a flash off-camera (or point it up away from the glass if it has a swivel head) so that glare from the glass doesn't ruin your picture. You'll eliminate the glare and produce light that looks more natural.

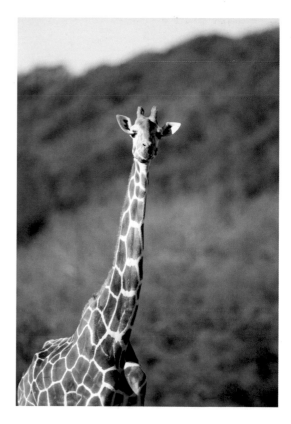

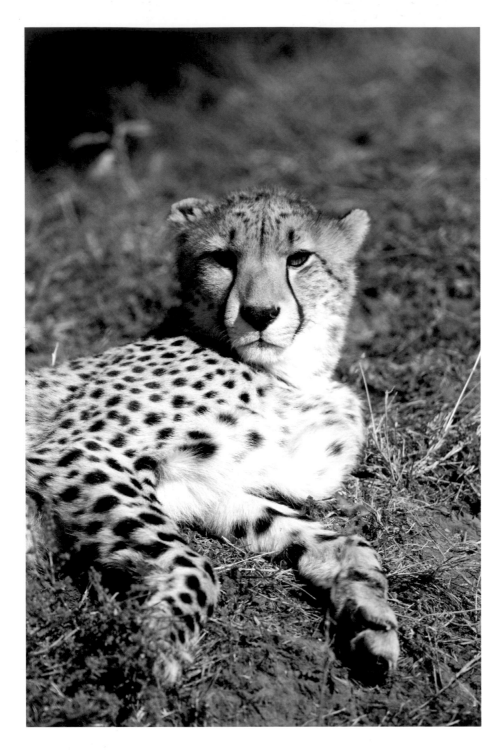

Shooting on Public Land

Most of us live within a reasonable distance of public land. It may be a city park, state park, or federal land like a wildlife refuge or bureau of land management land. Each of them offers great places in which to shoot photos. In these cases, a little advanced scouting goes a long way. For example, in the small town in which I live, I noticed that a number of wild waterfowl flew into a nearby park lake every winter. Most of the time, the ducks and a few geese took up winter residence there. After a while, the waterfowl became used to people and they would readily come to the crumbs of bread that people would throw to them. So now I take my kids to the park and let them throw bread to the ducks while I take pictures.

As a result, I have taken some of my finest waterfowl shots just a few blocks from my house.

State parks and wildlife refuges offer the same opportunities as city parks. Since they are visited so often by humans, the animals become habituated to human activity and aren't as fearful as they may be in more rural areas that don't get much traffic. As a result of their ease around humans, animals like deer will carry on naturally even though you may be standing mere yards away in plain sight. I've shot pictures of animals displaying all sorts of unique behavior, and they couldn't have cared less that I was there. Besides wildlife, state and federal lands also offer scenic vistas for those of you looking to shoot interesting landscapes.

Shooting on Private Land

I am a big advocate of photo shoots on private land. The landowners I work with are great guides and scouts, and I consider them to be part of my photographic team. Since most of the landowners I work with are farmers or ranchers, they spend a lot of time on their land, and all that time they spend yields great opportunities for me as they report on the things they've seen. I have gotten most of my best images this way, and the relationships I've cultivated with landowners ensure that I'll continue to get more great photos.

So, you might be wondering how much access to private land might cost. The answer is potentially nothing at all if you treat the land as if it were your own and take care of the landowner's needs. I am generous with prints and report back to the landowners often after I go onto their land. Little things make

all the difference. I have found that asking nicely will often gain me access, and providing enlargements of the things I photograph is a great public relations move. Having the right attitude towards the people and their land goes a long way.

Ten Ways to Get Invited Back

Since so much of the land where I take pictures is privately owned, it is of the utmost importance that I remain conscious of the land onto which I tread because one wrong move can mean I won't get invited back. The following tips can help keep your landowner happy and ease future requests for access.

1. Respect the land as if it were your own – When you invite someone into your home, you expect them to treat it with respect. Let that concept be your guide as you tread upon land that belongs to someone else. The golden rule of using someone else's land is not to do anything on someone else's property you wouldn't want done on yours.

2. Stay on established roads – Royce Siebman, a conservationist for the Natural Resource Conservation Service, looks with disdain on people driving off established roads, and he has the professional expertise to recognize the impact. "Grasslands are fragile ecosystems and soil conditions affect how grass grows," emphasizes Siebman. "I have seen tire tracks made on a pasture that still exist several years later." Driving your pick-up or all-terrain vehicle off-road may be fun for you, but it can do serious damage to the land. Unless you have a landowner's explicit permission, stick to the existing roads.

3. Leave gates as you find them – Rotational grazing (the practice of allowing animals to graze only in a certain area while other areas are allowed to "rest") could explain why sometimes you go into a pasture and a gate is open and the next time it is closed. The best rule is, unless you have been given instructions to the contrary by the landowner or manager, leave gates as you find them. Cows may appreciate open gates, but the landowners might not.

4. Offer to help out with chores – There is perhaps no better way to show a landowner that you care about their place than by offering to help with chores. Imagine someone offering to mow your lawn. Sounds great, doesn't it? Now, maybe you can appreciate how farmers or ranchers may feel when you offer them a little respite from their busy schedule. Perhaps they have a shed that needs a fresh coat of paint, or you could pick up some items they need when you go into town for lunch. The idea is to be attentive to the needs of the landowner and offer to help whenever you can. And most importantly, offer your help free of charge. Do it as a goodwill gesture and a way of offering your thanks. Whether you pay for the privilege to explore their land or not is immaterial. The point is to be a good neighbor and a good guest.

5. Give gifts – If you are new to a place and are just getting to know the owners, a gift is a great way to say that your new relationship means something and you want to see it continue. The right to access land can grow into a friendship in which both of you have a mutual interest in the continued productivity and care of the land. Gifts don't have to be extravagant; pictures of a deer you took in one of their pastures may fit the bill. Cards sent on birthdays, holidays, or anniversaries and occasionally stuffed with a restaurant gift certificate can also go a long way toward telling landowners that you cherish the privilege they have provided you.

6. Make litter your business – You know how unsightly litter is along public roadways. Well, it looks even worse on private lands. Never, under any circumstances, throw trash on the ground, and if you find any trash, even if it isn't yours, pick it up. Smoking should also be avoided. Throwing cigarette butts in pastures is a good way to not be invited back. Plus, in fire-prone areas, a misplaced cigarette butt can cause untold economic and environmental damages.

7. Understand your privileges – When you first secure permission to go onto private land, make sure that you and the landowner have a clear understanding on the matter of your privileges as a guest on the property. For example, are you allowed to bring family members or other guests? Unless the landowner specifically grants permission, inviting others is a quick way to lose access. Think of all the guest scenarios you possibly can and get answers about them before you start planning a trip. It is always safer to ask a lot of questions initially instead of making assumptions about what you are allowed to do.

8. Report anything out of the ordinary – This point goes back to being a good neighbor. Keep an eye on things like the fences. If you see a strand of fence wire broken or a post uprooted, tell the landowner. He or she will appreciate your help in solving or averting a potential problem. Also, be on the lookout for illegal trespassers, livestock in trouble, washed-out roads, water supply problems, or anything else that doesn't seem right. Become the landowner's partner in preserving the economic and ecological well-being of the land. By doing so, you will make yourself welcome for many years to come.

9. Play by the rules – Whether you are taking pictures or just observing wildlife, never put picture-taking or getting a good look at the animal over the welfare of your subject. Harassing wildlife is unethical and shows lack of respect. Treat the land and animals on it as if they were yours.

10. Communicate, communicate, communicate – Communication is probably the most important concept to grasp when it comes to getting along with landowners. At the initial meeting, get any potential issues such as guest privileges or limit to visitation times on the table so they can be discussed and fully understood. Once the provisions for your visitation have been ironed out, make it a point to sit down as often as possible with the landowner to visit as friends. Also, be sure to call ahead and let the landowner know whenever you'll be on their grounds. Effective communication is a two-way street; make sure that the landowner can get in touch with you when necessary, and make yourself available if at all possible when they want to meet—even if the light is great for taking photos.

Using Feeders to Attract Wildlife

One of the secret weapons I use to get pictures of wild animals is the use of feeders and feeding stations. Animals have to eat, and by providing feed for them, I feel that I am helping them through the tough times in the winter when food is sometimes hard to find. I also keep food out all year in the areas where

I photograph so the animals have a constant food source. The premise I go on is the same one I use for feeding songbirds in my backyard: I want to provide a single place that wildlife congregates in order to make the most of my photography outing. The feeders I place in the field are big, the same type as hunters often use. Essentially, the feeders are 55-gallon barrels with tripod legs. On the bottom of the barrel is a spinning mechanism that is battery powered and regulated by a timer. I can set the timer to dispense the food at preset times when the animals are likely to be more active. Additionally, I am able to set the amount of feed the unit dispenses.

When I deploy a feeder, I typically have a species in mind that I want to attract. For example, when I photograph turkeys, I'll scout an area and figure out where the turkeys are traveling. Several weeks before I want to photograph them, I'll deploy a feeder in an area where I think the light and background is well suited for photography. Soon thereafter, I'll build a blind of natural materials or use a portable blind just yards away from the feeder (see pages 69—73 for more information). Filling the feeder with hard kernel corn, I'll set the unit to dispense just before sunrise. When the turkeys fly down from their roost, breakfast is served. I've found that turkeys become habituated to the feeder and will visit them almost every day for a quick bite before heading off to the brush. If the turkeys don't show, some other kind of animal like songbirds or an occasional deer nearly always shows up to eat.

One note of interest pertaining to feeders: I never use them on public land because it is illegal in many public parks to feed wildlife. Additionally, because of lack of security, the feeders can easily disappear. Therefore, I only place feeders (with permission from the landowner) on private land where I can closely monitor them to make sure food is always available to wildlife, whether I am photographing or not.

out into the field. Even when I shoot pictures in public areas where the wildlife is used to being around people, I still wear camouflage so I can maintain a subdued presence and allow the animals to stay calm and act naturally.

I cannot express enough the importance of camouflage. I know some people disagree and say that neutral tones are enough to stay inconspic-

uous, but I disagree. Camouflage works wonders by breaking up your human outline so that you're not as likely to spook an animal when it sees the familiar human form. Most importantly, I believe, camouflage is effective because it helps conceal movement. If you are still, you can nearly hide from wildlife wearing a t-shirt and jeans. The instant you move, though, you'll be spotted and the animal will flee.

Blinds and Camouflage

Since most of my shooting is of wild animals on private land, using blinds and camouflage is absolutely essential for my success. I suspect that a good number of animals I've photographed may have never seen a human before. Therefore, I think that camouflage is important and I wear it almost every time I head

Modern camouflage patterns and materials are pretty impressive. You can purchase photo realistic patterns that match the terrain where you are working. You can even buy clothing that is carbon lined to eliminate human scent. Scent elimination is especially important if you plan to shoot pictures of wild animals like white-tailed deer that use their sense of smell as their first line of defense.

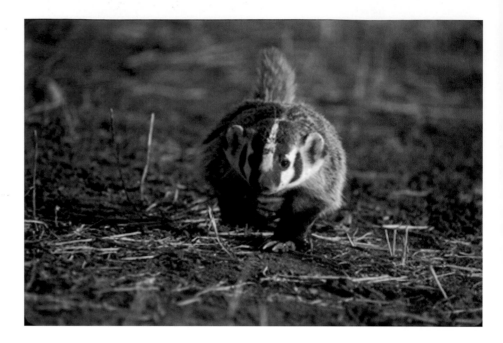

Blinds are also important in my photographic arsenal. (Refer to the following section for details.) When I am on a good wetland or game trail where being mobile isn't important, I'll build a blind from locally gathered natural materials. Ultimately, I want to stay hidden. The better I hide, the more likely I am to get a great shot from my location.

Hiding in Plain Sight

Whenever I can, I haul a blind with me into the field. Blinds can hide a stool, a camera, a tripod, and me. Since I've started using a blind regularly on my shoots, the time I've spent in the field has become much more productive. With a little effort and preparation, I'm able to come home with images that find a place in my keeper file.

Although made for hunting, the blind is incredibly useful for photography. They set up quickly and are very portable. They take about ten seconds to erect and about a minute to pack away. Whenever I use the blind, I usually do not use the ground stakes or the roof support rods. Since I sit in the blind, the roof sag doesn't bother me. Good blinds will have landscape appropriate camouflage on the outside and be lined in carbon to help mask human odor. Because the blind is camouflaged, I often wear shorts and a t-shirt inside for comfort when the temperatures outside rise quickly. I have one blind for warmer weather and one for colder weather, the cold weather version being of heavier material.

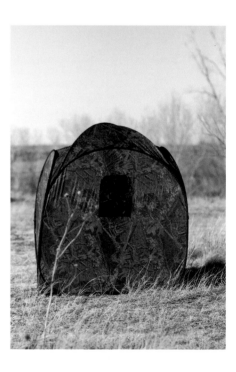

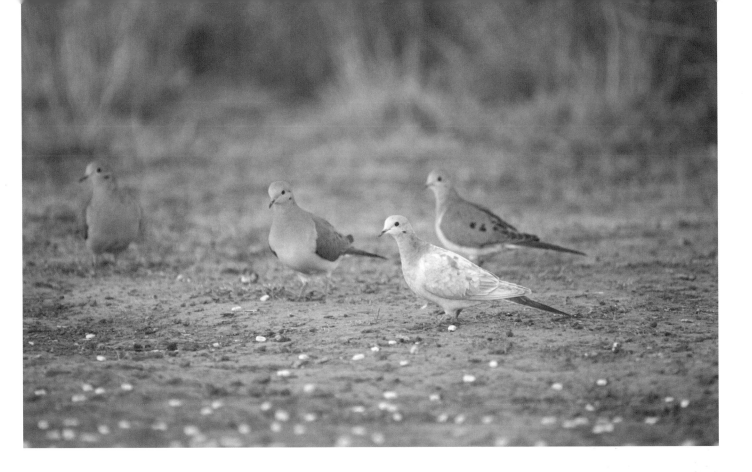

When incorporating a blind into my photography endeavors, I take several variables into account: wind direction, travel corridors, and feeding areas all play a part in helping me decide where to set up. Before I go to a new place, I scout the area. Then, I take the direction of the morning and evening sun into account when deciding on a place for the blind, as direction of light is extremely important for successful photography.

Some of the most productive locations I've found for placing a blind are near game trails. To hold wildlife, I'll put out feed or even a game feeder. I prefer using game feeders when I have long term access to a piece of property, because I can habituate the animals to coming to the feeder at a time of day when the light is best. (See pages 68–69 for more about using feeders.)

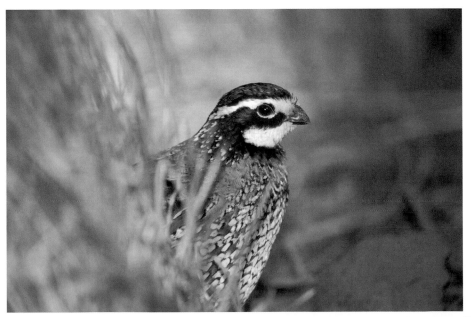

When I plan to spend a morning in a blind, my setup is straightforward: I simply drive to the spot, drop the blind and my camera gear off, hide my truck a few hundred yards away, and walk back to the blind and set it up. Most often, I position the blind so that I can shoot out of two windows that are at right angles to one another. I've found that if you open up windows opposite one another, animals can see your silhouette against the openings. Once inside the blind, I settle onto a padded bucket and flip through a magazine to pass the time while I'm waiting for the action to heat up. Of all the animals I've seen and photographed from the blind, I concede that deer and coyotes, so far, show some leeriness.

Making Your Own Blind

If I have private land access, I'll often build my own blinds for concealment. Private land is the key term here because cutting vegetation is prohibited on most state and federal lands. With that said, depending on the situation, I'll build one of two types of blinds.

The first blind is a permanent one. Permanent blinds are ones I plan to use for a long time so I am willing to put quite a bit of work into them. Planning starts by picking a good location and keeping the sun

in mind. After considerable time scouting, I'll find an area where I think wildlife will be plentiful and locate the blind where the sun will be at my back. Since I've scouted the area, I know whether the blind will be primarily for morning or evening shooting. Once I've decided, I get to work on the build.

When I begin construction, I select a spot that is relatively flat and has good drainage so the spot won't stay muddy should it rain. I also clear out an area big enough for me to stretch out so I can be comfortable during long stretches of time. I usually build pretty simple blinds: four walls with little or no ceiling. For each corner, I use a steel fence post planted upright in the ground as my primary support. Steel posts are cheap and readily obtainable at just about any hardware store. With the base set up, I gather materials

from the immediate area with which to cover the blind. I look for dead limbs, bunches of dead grass, old wooden fence posts, or other material that looks like it belongs.

I then wire the hardest material to the fence posts to build the walls. The hardest material may be limbs or old wooden posts. At this point, remember to leave a slot for your lens at the level at which you plan to sit. It is always a good idea to bring a stool along to make sure your photo opening is at the correct height and you've built your walls far enough apart for comfort.

The last step in the build is to attach soft material like grasses or shrubs to the outsides of the walls. The objective is to cover the blind with enough material to conceal any movement on the inside of the blind. I even put burlap around the inside of the blind to conceal myself

even more. The burlap also helps to break the wind that always seems to blow on the coldest mornings.

When I think the construction is complete, I'll get on my hands and knees and look at the blind from a distance. I try to be at the level of the wildlife I'll be photographing and see the blind the way they'll see it. I look for any holes in the walls where they are liable to look in and see me. After that, I add material as needed each time I use the blind.

The other types of blinds I build are temporary blinds. These temporary blinds are essentially "one hit wonders." I use them as needed and leave the material behind. For example, if I am setting up on a deer trail near my home, I may collect a few tumbleweeds and pile them around my tripod. Then, I may find a forked branch and drape it over my lens to break up my and the camera's silhouettes. These types of blinds are quick and easy and work great when you need fast but effective concealment.

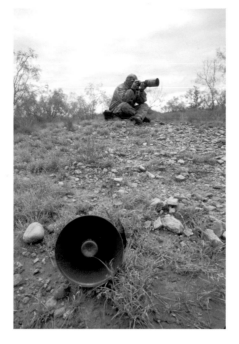

Dress for Success

Looking up through the trees I can't help but notice how a midnight scouring by a strong arctic cold front makes the sky an intense shade of cobalt blue. The strong winds came overnight, but now on this patch of northeast Texas, the wind is light and barely discernable except for an occasional puff of cold wind in my eyes. I sit down and try my best to mimic the sounds of a distressed cottontail rabbit. Five minutes later, a coyote comes strolling in from the west. Dressed in full camouflage, I sit quietly until he's 20 steps in front of me. With the sun bathing him in an ochre shade of evening light, I fire off a few frames and capture the moment. The whirring of my motor-driven camera gets the canine's

attention and he looks my way. I am camouflaged from heel to toe and although he looks my way, he cannot tell what I am. Nervous, he slinks away into the cedar thicket. I am left with a handful of great coyote pictures. I am convinced that my camouflage did the trick. In fact, I am sold on camouflage's role in helping to make me a successful photographer. Although I do my share of photographing from a blind (see pages 69–73), many of my images are taken sitting in the brush amongst the wildlife.

Hide Where They Live
Various kinds of camouflage hang in my closet: Realtree (by Jordan Outdoor Enterprises, Ltd.), NaturalGear, Mossy Oak (by Haas Outdoor, Inc.), and Sage Country

Camo are a few of the brands that make up the repertoire of clothing I use for photography. Many how-to photo books suggest that camouflage is unnecessary and that you should wear drab colored clothing to blend in to the surroundings, but I disagree.

For shooting wary creatures like predators or white-tailed deer, camouflage is essential, especially when you don't have time to set up a blind and are relegated to shooting from the ground. I am convinced that for close encounters with wildlife, head to toe camouflage is absolutely necessary.

The trick is to think like a hunter. When I make a ground blind out of natural materials, I check that there's enough material to screen me from all sides. The problem is, however, that ground blinds are a bit limiting because you have to leave enough space so you can take pictures without distracting limbs in the way. Since you can't conceal yourself completely with natural materials, full camouflage is best: shirt, pants, head net, cap, and gloves all make up my camouflage attire. The only variation in my dress is from season to season.

Dressing Up

Winter brings special challenges to the nature photographer. Clothing should be warm, yet not restrict movement, and as outdoor wisdom suggests, I dress in layers. The hard thing about dressing for winter is finding gloves that suit me. Since the knobs and buttons on my camera are small, I need gloves that are tight enough to allow me to articulate the controls as if I had no gloves on at all. I've tried mittens that I slip on and off and fingerless gloves, but they still do not work well for me. Instead, I opt for tight-fitting camouflage gloves. The gloves protect my hands from the cold camera and metal tripod and add a bit of insulation (though not much, I admit). To keep my hands warm while I'm waiting for wildlife to slip by, I use a hand muff. The muff straps around my waist so I can put both hands in it and slip them out easily when the action heats up. For my face, I have to be careful about what kind of facemask I select. I've tried balaclavas made from polypropylene but the material forces my warm breath up and it escapes through the eye opening and fogs up the viewfinder. Instead, I've found that a heavy fleece facemask works well and traps most of the condensed air as I exhale.

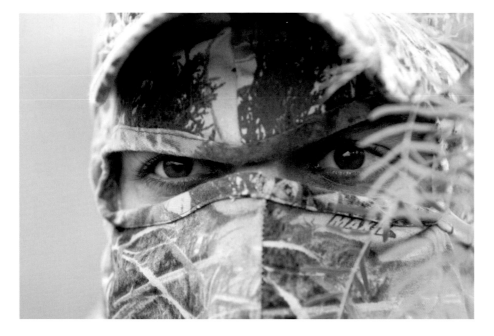

Dressing Down

As the weather grows warmer, my dress doesn't change too drastically. I still dress in full camouflage, only with less layering and a lighter, mesh facemask. I still wear the same tight-fitting gloves that I use when it's cold, but now my concern isn't warmth so I eliminate the hand muff. During warm months, I will, however, change my footwear. When it's cold, I wear insulated boots, but as the weather warms, I switch to knee high hunting boots. The boots work great for me, as they cover nearly all of my lower legs save for a couple of inches below my knee. Their leather and nylon construction makes them waterproof, briar and thorn proof, and most importantly, snake proof. As the weather gets really hot, I may opt for a long sleeve t-shirt instead of a button down shirt. All the clothes I use for nature photography are made of wool or cotton or fleece because they allow for quiet movement.

Selecting a Pattern

To increase your chances of getting a great image, you have to get close. Some nature photographers forget that the right clothing is just as important for getting shots of wildlife as a big telephoto lens. The bottom line is that what you wear when photographing is a personal thing. Ultimately, I believe that you cannot wear too much camouflage when pursuing wary creatures. Choosing a camouflage pattern is very simple. Take a picture of the type of terrain where you plan to photograph and match it to one of the scores of patterns available on the market. The next chance you get, peruse the Internet for camouflage companies and you may be surprised at what you find.

There are enough patterns out there to hide you in just about any terrain; there are even snow patterns to match the mixed colored terrain after snow falls. Give camouflage a try and you'll see how effective concealment is in helping you get closer to wildlife.

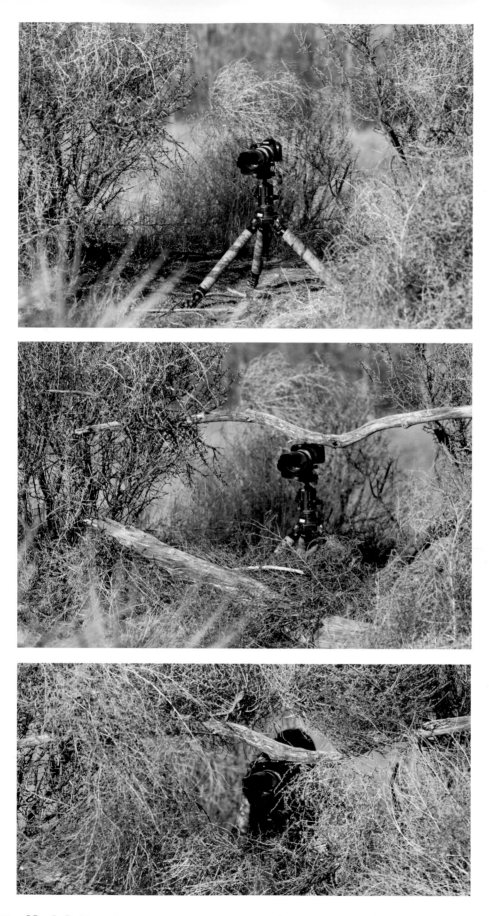

Using Decoys

In one form or another, decoys have been around for thousands of years. Early hunters constructed fake animals from wood and straw. Now, decoys are made of plastic or high-tech fabrics, and the technology associated with decoy construction continues to evolve.

For decoys to be effective in attracting animals, you have to understand each species' biological needs. Deer decoys work best during the breeding season, since bucks are looking for does to breed or other bucks to fight. Turkey decoys, like those for deer, also work best during the breeding season. Waterfowl and predator decoys, on the other hand, appeal to an animal's hunger. Ducks congregating in shallow water draw other hungry ducks, and the sight of a rabbit in an opening is a strong visual feeding cue that coyotes find hard to ignore.

Turkeys

Because of their keen eyesight and sensitivity to the smallest of movements, turkeys are one of the most difficult animals to see up close. Some experts contend that if turkeys could smell, they would be nearly impossible to successfully to get close to. Boss tom turkeys do have one serious weakness, though: hens. In the spring, male turkeys strut, making flamboyant feather

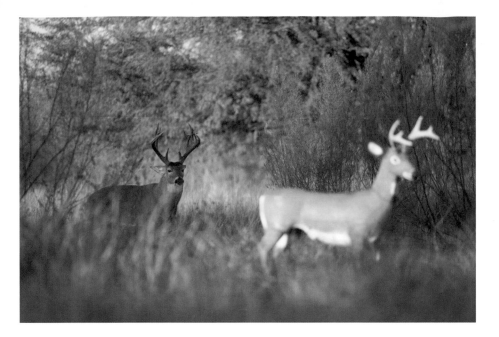

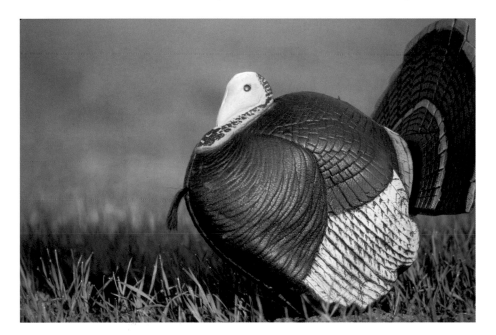

breeding pairs, and feeding and alert hens. Although I cannot say that one works any better than another, I can say they all work well in attracting a tom's attention.

Early in the spring strutting season, just as breeding begins, hens are more receptive to the males and the toms largely ignore decoys. However, as the season progresses and receptive hens become scarcer, decoys become more effective. If you have trouble attracting turkeys in the morning, try your setup at midday. Hens sit on their nests during the middle of the day and are unavailable to the toms. If a tom sees a lone hen, he is likely to investigate. Decoys work great for holding toms in an area close to your photography or bird-watching blind. The trick is to figure out the travel patterns as the turkeys move to and from the roost.

displays to attract females for breeding. Strutting toms are single-minded in their approach to females. I have seen toms follow hens for an hour or more, with their feathers fully extended, jockeying for position against other males as they compete for the hen's attention. If you are interested in photographing or watching turkeys, get a decoy and place it in a highly visible location. A number of manufacturers offer decoys in such different positions such as strutting jakes,

Predators

Predators such as coyotes and bob-cats are a challenge to decoy. Their super-tuned senses make them naturally wary, and getting them into camera range—or even binocular range—is a difficult task. It's essential to disappear visually. A camouflage pattern that matches the surroundings helps mask the visual signature, while a cover scent such as commercially available skunk spray or raccoon urine helps mask the human odor.

Next, invest in a good predator call. For do-it-yourselfers, a myriad of mouth-blown calls are available. Some manufacturers make electronic callers that play CDs or microchips, as in the image above. Electronic calls are great for delivering a consistent sound repeatedly, but you cannot customize the sounds with voice inflection.

The last step in successful predator calling is the decoy. Predator decoys range from commercially manufactured decoys to a stuffed animal that you take from your child's bedroom. The combination of an appealing sound coupled with a visual stimulus is often too much for a predator to resist. A great side benefit of using decoys with predator calls is that you are likely to call up a host of other animals such as songbirds, owls, and hawks.

Place predator decoys in a low-grass clearing so an incoming coyote will spot it easily. The trick in predator calling is to redirect a predator's attention so it will not spot you sitting in the bushes. To add a little movement to your decoy, tie on a bit of monofilament string and occasionally give it a tug, especially as predators start to home in on your location.

Deer

In the long chronology of decoying, deer decoys are a fairly new phenomenon. Manufactured primarily for hunters, decoys offer visual stimulation that complements the antler rattling that people sometimes use to attract deer. Made in full-body and silhouette styles, deer decoys are effective at holding deer in an opening. The first time I used a deer decoy, it kept a huge buck in an opening for 10 minutes staring and circling the fake doe. He never approached the decoy any closer than 10 yards, but the decoy fascinated the buck to the point that he completely dropped his guard. Although deer decoys might sound cumbersome, many decoys have detachable heads, limbs, and antlers, making them easy to carry to and from the field. Some compa-

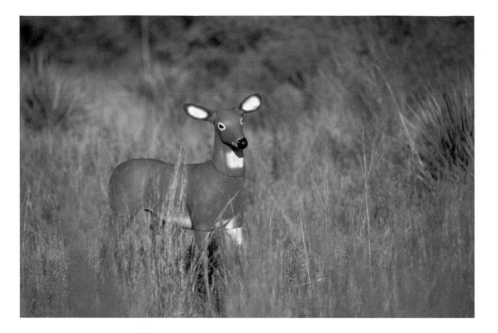

nies manufacture a photo-realistic decoy that folds up small enough to fit in a backpack and weighs just a few ounces. Since deer have an acute sense of smell, spray your decoy down with commercially available scents such as doe-in-heat spray or scent eliminators. When you get back home, you can hose the smell off plastic decoys with water. And keep in mind, since deer decoys are so realistic, avoid using them during deer hunting season. If you do decide to use a deer decoy during hunting season, wrap it in fluorescent orange tape while you haul it to and from the field. That way, you and the decoy are highly visible to others.

Game Birds

One of the most amazing decoys I used this past year was a battery-operated mourning dove decoy with wings that spin. The wings are white on one side and gray on the other, and when they turn, they create the appearance of the flapping of a landing dove. The first time I used the decoy, a hundred doves turned and flew past it. A bunch of doves landed beside the decoy and a few even tried to land on it. While I crouched in a blind a few feet from this decoy, meadowlarks, sparrows, grackles, and other non-game birds also landed near it. The reason, I presume, is simple: When doves land on the ground, they feed. Other birds recognize the feeding posture and come to join in. Dove decoys work great around food sources such as sunflower or milo fields.

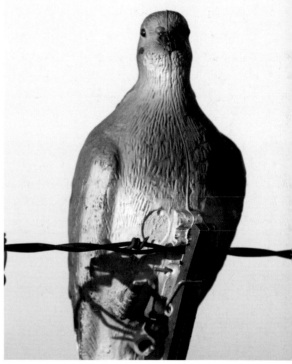

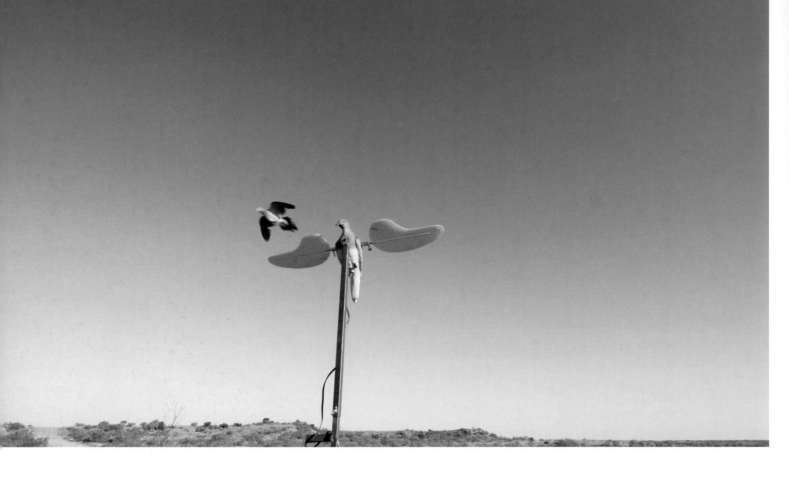

Static decoys (such as dove decoys that clamp onto limbs) also work well for attracting doves and other birds. For fun, I made my own quail decoy out of a block of pine and had a friend paint feathers on the wood. I was curious to see if the decoy would work well to attract bobwhite quail, but discovered that the homemade bird acted more as a "confidence" decoy. I have seen quail, turkeys, doves and a host of other birds land beside my quail decoy and feed with complete confidence that the area is free from danger. To build my quail decoy, I glued three pieces of 2 x 6-inch (5.08 x 15.24 cm) lumber together, traced a quail pattern obtained from a woodcarving supply house, and cut the decoy out using a band saw. I spent half an hour cutting and shaping.

Waterfowl and Shorebirds

If you enjoy watching waterfowl or shorebirds, decoys are a great way to bring them close. Scores of manufacturers produce a huge variety of duck and goose decoys. Historically, most duck decoys have been of the full-body variety, with keels that keep them upright on the water. First made from wood, manufacturers now create virtually all full-body duck decoys from molded plastic. However, flat, photo-realistic decoy silhouettes are a growing trend in the duck decoy industry.

Goose decoys also come in full-body varieties, including rags, shells, and silhouettes. For waterfowl, one or two decoys are not sufficient. Instead, create a large spread of at least a dozen decoys and mix decoys of different species. If you are willing to spend a little extra money, motion decoys that mimic ducks feeding or landing add realism to a spread that the birds will find hard to resist.

When you decoy for ducks and geese, you will often attract shorebirds as well. While hiding next to a duck decoy spread, I have seen killdeer, avocets, and herons land and hang out along the shores nearby. Shorebirds feel comfortable around other birds, and you will be surprised at the different species that show up.

When laying out a duck decoy spread, a good general rule is to place the decoys in a semicircular pattern leaving a "hole" in the middle of the decoy spread. Incoming ducks will land in the hole before fanning out to feed. To add even more realism to a duck spread, add one or two heron decoys. With geese, a mix of shell and rag decoys works great. The shells give a realistic dimension to a spread, while the rags add movement and increase realism.

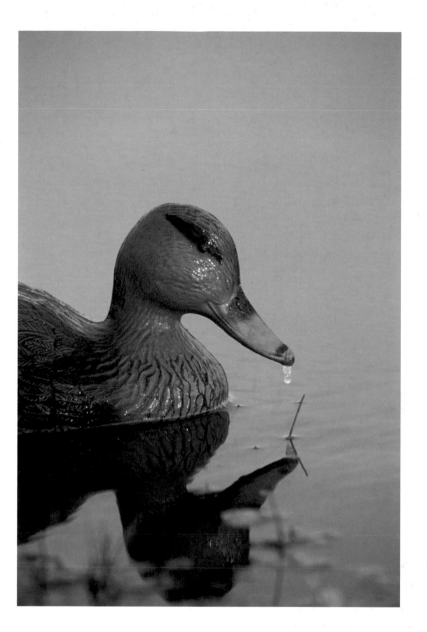

5

If you're like me, you are a hands-on, learn-by-doing kind of person. I work best when I see some examples and try to mimic the things I see. That is what the beginning of this chapter is all about. Following are several examples of memorable pictures that came as a result of planning and execution.

The second half of this chapter focuses on what to do with your images once you've captured them. I will share my digital workflow and organization tips to help guide you towards creating a system that works for you. The key to dealing with lots of digital images is staying organized and working efficiently.

Case Studies and Creating a Digital Workflow

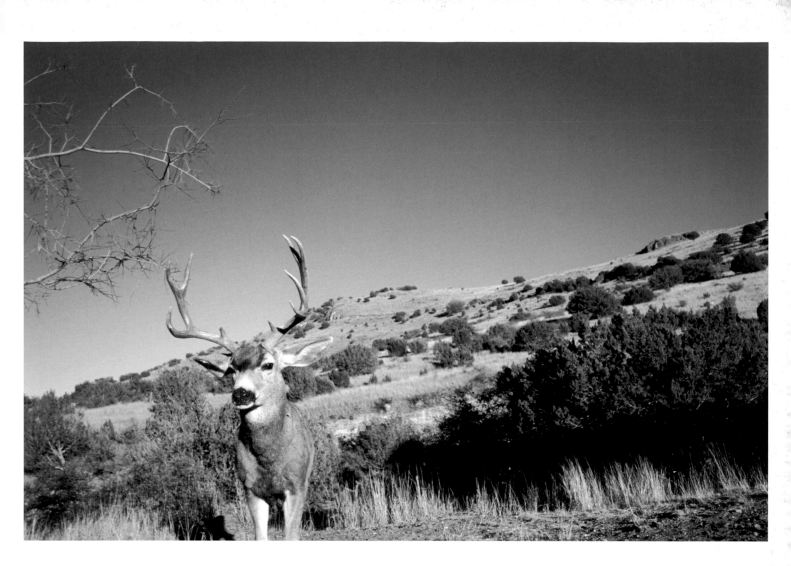

Case Study 1:
The Mule Deer

This is one of my favorite wildlife pictures. I was in a state park where I knew a lot of mule deer roamed. I had plenty of standard mule deer body shots on hand, but for this shoot, I knew I wanted to try something different. As I hung out in the park, I quickly found that the deer were very friendly and were staying close to me looking for a handout. Then I had a great idea. The park was comprised of beautiful high desert mountains dotted in juniper trees. So, I decided to combine the mule deer in the same picture as the beautiful landscape.

With wilder animals, combining the animal with its environment would be easy. All I would need to do is back up and put some distance between myself and the wildlife. However, every time I tried to back up, the deer would follow. My solution was to use a wide angle lens so I could get all of the elements I wanted in the scene and produce a memorable image. I sat on the ground, waited for a buck to walk near, composed the image, and fired a couple of shots.

Tech Specs:
- 20-35mm zoom lens set at 20mm
- Shutter speed: 1/125 second
- Aperture: f/16
- ISO 100

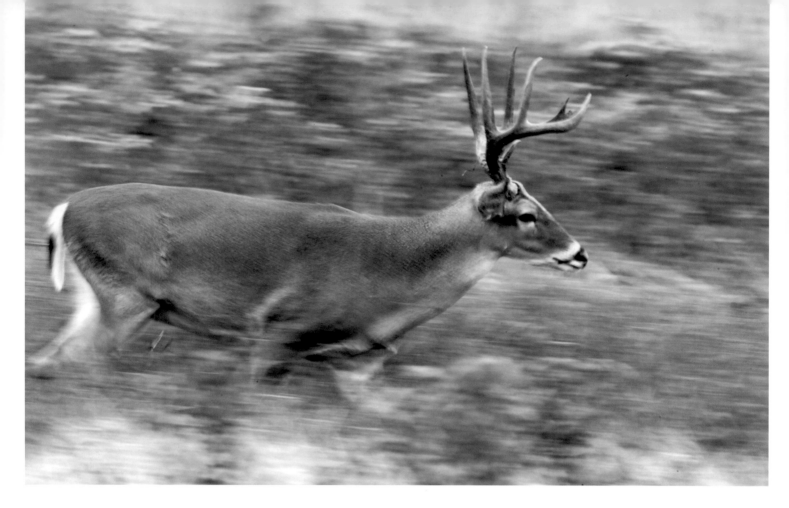

Case Study 2: The Running Buck

Like mule deer, I am almost out of hard drive space because of the scores of white-tailed deer images in my files. So on a December shoot, I was in the mood to try some creative techniques. Since white-tails have a skittish nature, I knew it would be hard to come up with creative approaches to photographing them. I also knew I couldn't shoot them with a wide angle because I couldn't get very close, and telephoto shots of them looking at the camera were already overrepresented in my collection. Therefore, I decided to do some slow shutter speed panning.

Shooting slow-speed pans is easy. Use a slow shutter speed and follow the action. To shoot this image, I set my camera on shutter priority. That way, I set the shutter speed and the camera selects the appropriate aperture to match my shutter speed. Once my camera was set, I waited, and when the deer ran, I shot the picture.

Tech Specs:
- 300mm lens with 2X teleconverter
- Shutter speed: 1/20 second
- Aperture: f/8
- ISO 100

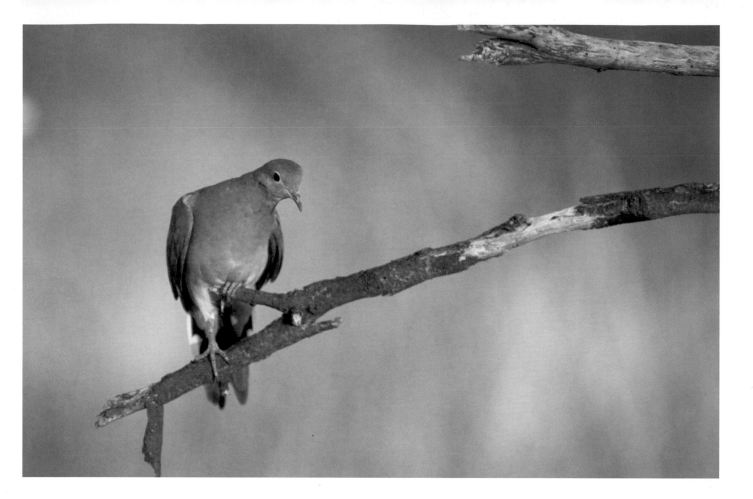

Case Study 3: The Mourning Dove

I love it when my plans work out. In this shot, I set out to get a picture of a mourning dove on a dead limb with a clean background. I see mourning doves all the time, but they are usually in trees with lots of dead limbs. Shooting pictures of them is difficult sometimes because they get lost in all the visual clutter.

I planned every aspect of this image completely. First, I dug a hole and "planted" a dead tree with a single horizontal branch. For a week, I went out every day and poured bird seed below the limb and just in front of it. My intention was for birds to use the limb as a perch and a staging point before they jumped down and fed on the seed. On the morning I planned to shoot, I got to the spot about an hour before sunrise and set up my portable blind a few feet east of the limb and settled in for a wait.

Just after sunrise and right on cue, a mourning dove flew down and landed on the perch. Since I knew where I wanted the birds to land, I aimed my tripod mounted camera on the limb and pre-focused. When the dove landed, a quick check of the composition and focus was all it took. I pressed the shutter button and nailed the shot.

> **Tech Specs:**
> - 300mm lens with 2X teleconverter
> - Shutter speed: 1/250 second
> - Aperture: f/8
> - ISO 100

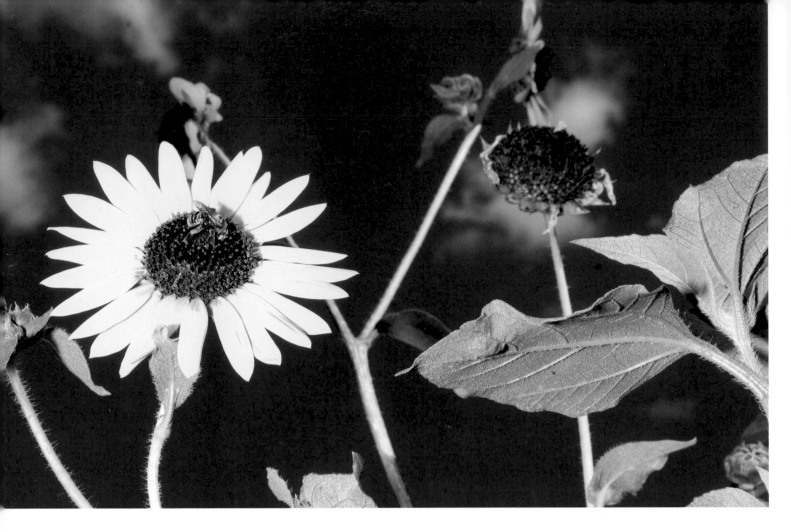

Case Study 4:
Backyard Flowers

I grow a variety of wildflowers species in my backyard to attract wildlife, and sunflowers are among my favorites. For months, I watched the sunflowers grow until they became bright yellow beacons against my back fence. One evening while I was in the backyard with my kids, I decided to try to make a memorable portrait of something that most may see as mundane. Choosing a low angle, I wanted the sky to dominate the image. In this photograph, I pointed my camera at the sky, took note of the camera's meter reading, and then purposefully underexposed the image by one f/stop in order to darken the sky in the background. I also used a small aperture and slower shutter speed in order to get both the clouds and the flower in focus. Ordinarily, the flower would be dark and lack any color detail because I underexposed the whole image, but to offset that, I mounted a flash on the camera to light the sunflower. In all, I think I got a pleasing image, and I only had to walk out my back door to accomplish it.

Tech Specs:
- 20-35mm lens set at 20mm
- Flash
- Shutter speed: 1/60 second
- Aperture: f/16
- ISO 100

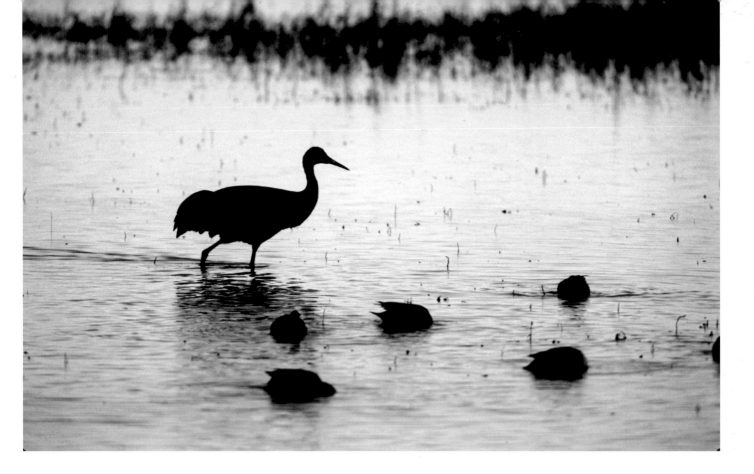

Case Study 5:
The Wading Crane

Silhouettes are among my favorite images. Many other people like them as well, and I am constantly fielding questions about the technique and how to pull it off. I am happy to report that shooting pictures like this one is incredibly easy.

When I saw the crane wading around in the shallow water at sunrise, I knew it would make a powerful image. All I did was wait a couple of minutes until the crane stepped into a clear area so I could take a more pleasing photo of the bird. To accomplish this, I first set my camera on aperture priority mode. That way, I set the aperture and camera matches it with the appropriate shutter speed. The next thing to bear in mind is that the key to good silhouettes is having a big area of highlights like the sky, or in this case the water.

Make sure the subject of your photo is in an area where it is surrounded by light areas. In other words, since all of the darker areas in the picture will go black, you won't have any separation in the subject and anything it appears to touch. For example, if the crane in this image were next to one of the ducks, they would blend together because I am exposing for the bright areas in the image, not the dark ones. Cameras can't record a broad range of tones very well, so when you expose for the light areas, the darker tones go black. On the other hand, if you expose for the dark areas, all of the water would be white and the detail washed out.

Tech Specs:
- 300mm lens
- Shutter speed: 1/2500 second
- Aperture: f/5.6
- ISO 100

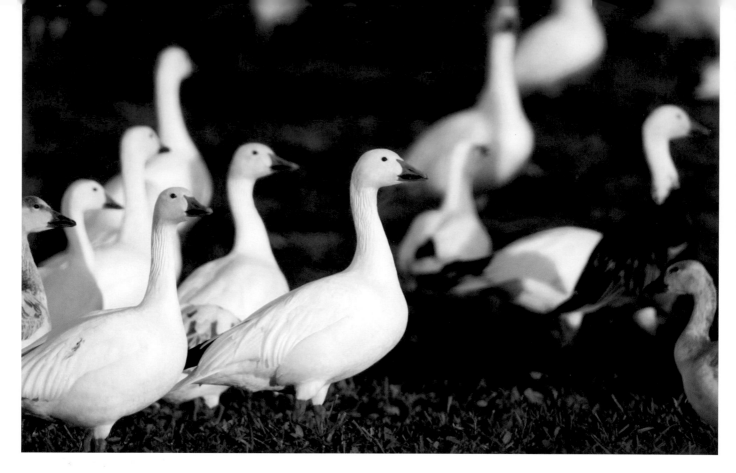

Case Study 6:
Tricky Exposures

One of the most challenging images to get right is a white subject on a dark background (or vice versa). When a camera's light metering system sees this contrast, it wants to average the two together. The result will be blacks that aren't quite black and whites that look gray. My advice in handling a situation like this is to find an area that is middle toned. In this case, I aimed my camera at the northern blue sky and made note of what the camera told me the shutter speed and aperture

setting should be for that particular tone. Then I switched my camera to the manual exposure mode, dialed in the settings suggested by the camera, and shot the picture.

While I was looking through my camera's viewfinder at the scene, I noticed that the meter was telling me I had the wrong exposure because the light and dark areas had the meter fooled. Instead, I trusted my instincts and shot the picture with my camera set based

on the reading I got from the sky. The result is that the blacks look black and the whites, I am happy to say, look white!

Tech Specs:
- 500mm lens
- Shutter speed: 1/1000 second
- Aperture: f/5.6
- ISO 400

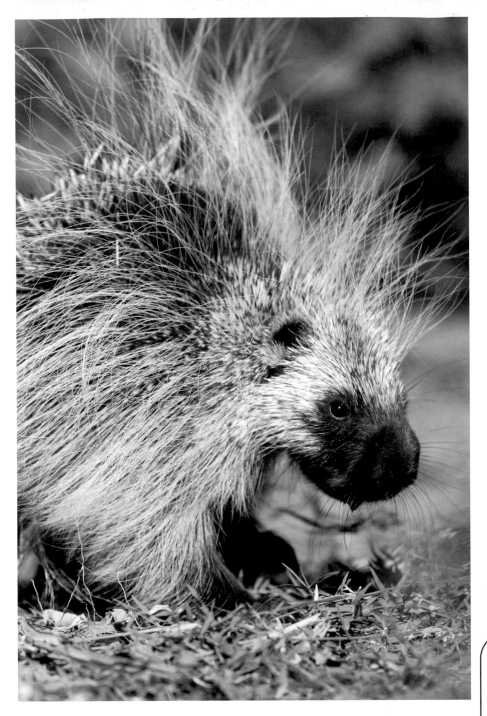

Porcupines are slow movers so I wasn't afraid of him running away. Once I got within a few feet, I laid prone on the ground. I've mentioned already that great wildlife shots look best when you get down at eye level with the animals you are photographing. For porcupines, you have to get really low. Ultimately, I am glad I did. This is an endearing image of a rarely seen animal.

Tech Specs:
- 70-200mm zoom lens
- Shutter speed: 1/500 second
- Aperture: f/5.6
- ISO 100

Case Study 7: Getting Low

Let's face it: How often do most of us see a porcupine? With a rare opportunity at hand, I had to get this picture nailed on the first try. I am outdoors a lot and rarely see porcupines, so when one was lumbering down a dirt road near my home, I eased from my truck, put the sun at my back, and crept as close as I could.

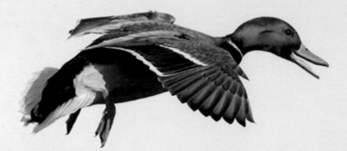

Case Study 8:
Flying High

I used to be a little afraid to take pictures of birds in flight because of the technical and financial limitations I had when I used film. When I switched to digital, however, the gloves came off and I was trying to take flight shots of any bird I could find. Many people think flight shots are difficult, but the basic technique isn't all that complicated. Granted, tracking fast-moving birds with a heavy camera and lens does take practice, but the technique can quickly be mastered. To take good flight shots, you have to learn to anticipate the bird's flight path and aim in front of it a bit by pointing the camera just ahead of the bird. Next, if the day is clear and the sunlight constant, take a meter reading off the northern sky, put the camera on the manual exposure mode, dial in the recommended exposure, and shoot away. The reason to use manual settings is that if a bird flies in front of a dark background, the camera thinks the exposure has changed even though the light source is of constant intensity.

Tech Specs:
- 300mm lens with a 2X teleconverter
- Shutter speed: 1/2000 second
- Aperture: f/5.6
- ISO 400

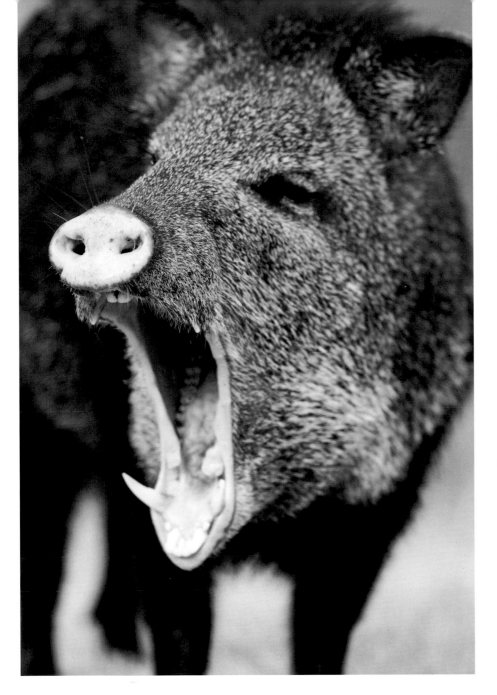

If you're reading this book, my guess is that you are already using a digital camera. Perhaps you're even a film photographer who has recently switched to digital and you're wondering what to do with all your new image files. Whatever your familiarity with digital photography, this section is geared towards showing you how easy it can be to develop your own digital workflow.

There is no right or wrong way of developing a workflow. I will outline the steps I take to give you some ideas, but keep in mind that this is just the way I do it. Refer to this section as a set of guidelines, not hard and fast rules.

Staying Organized in the Field

Born out of simplicity, I try to do the same thing over and over so that my workflow is automatic and becomes second nature. That way, I don't have to stop and think about what I am doing as the action heats up. To start with, I shoot all images in the RAW file format. (But as I mentioned earlier in the book, don't bother shooting in RAW rather than JPEG unless you are committed to spending time tweaking your images in the "digital darkroom.")

Establishing a Digital Workflow

With digital photography, every day is a learning experience because the cameras are great teachers. And like any good teacher, the camera provides instant feedback so you can learn from your mistakes and repli-cate your successes. The more you shoot, the better you'll become, and skills that used to take people a lifetime to master can be tackled in just a few years.

Out in the field, I always carry my memory cards in a card holder, and when I fill up a card, I place it back in the card holder face down. This way when I look at my card holder, I know instantly which cards are full and which are ready to use.

As for the image files themselves, many digital cameras allow you to imbed things like caption and location information as you shoot. For example, my cameras automatically imbed the time and date into the image. If your camera allows you to record such information, it is definitely something to consider. That way, several years and thousands of images later you can look back and know when and where specific images were taken and what they're of. This information downloads along with your image files when you transfer them from memory card to computer, and there are a variety of software programs on the market today that enable you to search images using dates and keywords that have been recorded with your files.

After the Shoot

One invaluable and inexpensive piece of equipment that I recommend you invest in is a card reader. These handy devices plug directly into your computer's USB port and stay there, acting as a dedicated drive for your memory cards. This saves you the hassle of plugging the camera into the computer each and every time you need to download images.

Edit and Rename

Once I am finished with a shoot, I insert my memory card into the card reader and begin browsing through each image, deleting ones that are out of focus, suffer from bad composition, are under- or overexposed, or have any other major problems.

Then, before I copy the remaining image files from the card onto my computer, I rename them.

My naming system isn't complicated; I just use my last name and a number (i.e., GRAVES-1). You might want to use the date of the shoot in your image number, or some other code that you will remember so you can tell what the image is just by looking at the file name. For example, if I were renaming images of ducks, a filename may be something like graves-du-1. The "du" is my simple code that tells me it is a duck image. With digital you can easily make your file naming system as easy or complicated as you wish, so just come up with something that works for you, and stick to it.

Download

Once I've edited out any images I don't want to keep and renamed the ones I do, I download them onto my computer into a general image file folder where I keep them until I sort them by subject. (This is what works for me, but you could also create a folder specific to the date, event, or subject matter of your shoot before you download from your card, then download the files directly there.) When the download is complete, I eject the memory card from the card reader (you may have to drag the icon on your desktop to the trash can) and delete all image files and format the card in-camera.

Note: Deleting the images from the memory card on your computer may work, but be aware that this confuses some cameras when you go to reinsert the card and use it. Your best bet is to delete the images from the card in-camera.

Note: Once you've erased all the images from the memory card, it is a good idea to format it. Formatting the card regularly helps optimize its performance. Check your camera's instruction manual for details.

Basic Image-Processing

After I download the images into my general image file folder, I do a couple more things before putting them away into a logical archival system. First, since I shoot all my images in RAW, they will all eventually need to be converted to JPEG (or TIFF, if you prefer). I don't do all of them in one sitting, but any images that I'd like to use right away for printing or to put up on my website get a quick run through Adobe Photoshop software for conversion to JPEG, a contrast boost, and resizing.

At this point, I've gone through my images twice and have had a chance to look over them again. If I missed a bad image on the first pass, I can delete it this time. The images I don't immediately process,

stay in RAW format until they are ready for conversion to another format. Keep in mind, though, that I always save the original RAW file and never delete it, even after conversion to another format. Whether you shoot in RAW or JPEG, it is always a good idea to save your original files and keep them separate from your processed files. Your original, unaltered image files are your digital "negatives," so treat them with care.

One idea that might work for you is to keep a folder called "Originals" inside the specific date, event, or subject folder you've created. That way, you can keep track of where the unaltered files are and find them easily. Also, be very careful not to overwrite your original files during processing. In other words, do not make changes to the file and then click "Save." You must select "Save As" and change the file name to reflect that it has been processed and avoid saving over the original image data. For example, if I had a duck image labeled graves-du-1, I might change it to graves-du-1_P to tell myself that this was a processed file.

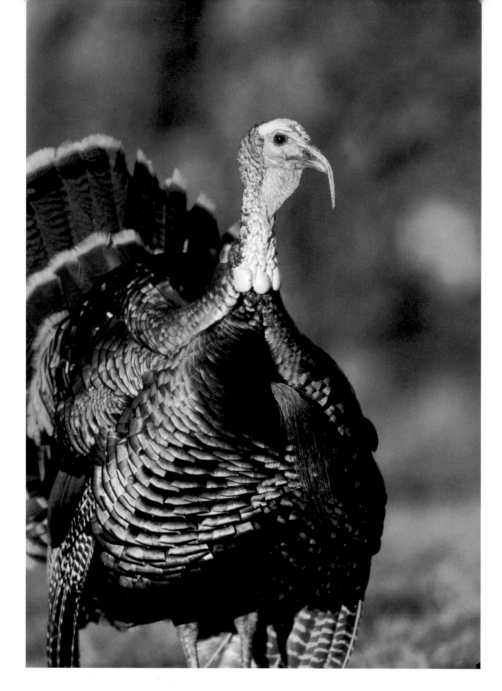

clicks. The slow part comes if I have to scroll through images and look for a specific picture. However, buying a browser software package that gives you the option of viewing your files as thumbnail-sized images makes locating a specific image fairly simple.

The system I use is one of hierarchal folders, and mimics the way that computers store files. I also set my browser program to sort the images in each folder by the date and time they were taken so that, if I can remember approximately when the image was taken, I can narrow down my search. For me this system is very intuitive, and I can locate images in a matter of seconds even when an image folder has a couple of thousand images in it.

Here are more examples of how my images are sorted into folders:

Agriculture > Crops > Cotton > Wheat

Birds > Game Birds > Song Birds >Wading Birds

Cattle > Angus >Beef Cattle > Calves > Dairy Cattle

Mammals > Mule Deer > Opossum > Prairie Dogs > Raccoon > Whitetail Deer

Organize for Later Image Retrieval

The next step in my workflow is to organize the images so that I can easily find them when needed. To do this, I place all of my images in subject folders and make sub categories based on the subject, scene, or activity in the images.

For example, when I shot this turkey image, I filed it like this:

Birds > Game Birds > Turkeys > Rio Grande Turkeys > Strutting

You can see that if I am looking for an image of strutting turkey, I am in the correct folder after just a few

Hopefully, you're starting to understand how this system works and what might work best for you. Keeping an organized archive of your digital files is doable. I spent a considerable amount of considering organizational schemes before I settled on the one I use. The system is not perfect, but it works for me. And with digital, changes come easy should I decide to change to a filing scheme that I deem to be more efficient. So start with something fairly easy and straightforward, then move on from there if you see that your system needs an update.

Color Management

If you don't print at home and don't plan to, feel free to skip this section. If, on the other hand, you plan to make your own prints with a high quality inkjet printer, it is important that the colors on your computer screen precisely match the colors that the printer produces. While it is somewhat difficult to calibrate the color output of most consumer model printers, it is fairly easy to calibrate your computer monitor.

Most computer monitors don't come calibrated, and the colors on the screen may not match what comes from the camera or printer.

So, for consistent color from camera to computer to printer, you need to think about monitor calibration solutions.

Take a look at any nature photography magazine and you'll see ads for monitor calibration units. A monitor calibrator lies against the computer screen, measures the color intensity, and gives you prompts for adjusting your monitor so that the images you see on the screen are of accurate colors that more closely match your camera and your printer. The art and science of monitor calibration and color management is enough to fill an entire book, but I mention it here so you'll be aware of these issues and consider tweaking your monitor to ensure accurate colors.

Conclusion

Each picture I have ever taken follows the same basic principles I have covered in this book. As I've said before, good photography is about doing the little things correctly time after time and being consistent. When I first started, I could take a good picture occasionally. However, consistency took time. With enough practice, I was taking good pictures 80 – 90% of

the time. A fitting analogy for this scenario is the sport of basketball. Beginners can make a shot every now and then, but the pros concentrate on technique and fundamentals until they hone their skills to the point where consistent performance is a given.

My challenge to you is to practice, practice, practice. Take lots of pictures, study the results, and take some more. I encourage you to send me your results, as I'd love to see your progress. Taking great nature photos, in my opinion, has a greater purpose than the manifestation of an artistic urge. Good photographs of the natural world are a way for you to learn more about the great outdoors. The more you learn, the better steward and conservation advocate you'll become.

A great collection of photographs is also a legacy you'll leave behind for your loved ones. I consider the thousands of photographs I've taken as a photographic diary. One day when I am gone, I hope my grandkids and great grandkids will see the world through my eyes and fall in love with wildlife and wild places the way I have. So go out and shoot pictures. You'll be glad you did.

A

Aperture 28, 29, 30, 31–33, 36, 53, 84, 86, 87, 88

Aperture Priority 33, 87

Autofocus 42

B

Backpack 19, 21, 47, 48, 79

Back-Up Storage 23, 24

Backyard 18, 62–63, 68, 86

Beanbag 46

Blinds 62, 68, 69–72, 74, 77, 79, 85

Blower Brush 47

Built-In Flash 18, 52

C

Camera Types
 Advanced Compact Digital Zoom 11–13, 14, 16, 18, 25, 53
 Digital SLR 10, 11, 12, 13–14, 16, 18, 20, 21, 22, 25, 53
 Point and Shoot 11–13, 14, 16, 18

Card Reader 92, 93

Close-Up Photography 10, 11, 14, 17

Clothing (see Dress)

Color Management 95

Camouflage 40–62, 69–75, 78

Composition 36–38, 39, 55, 85, 92

D

Decoys 76–81

Delete Images 38–93

Depth of Field 30, 32–33, 57

Dress 40–73, 75

E

Electronic Flash (see Flash Photography)

Exposure 19, 29–31, 34–36, 40, 52, 88, 90

F

Fill Flash 50

Filters 13, 14

Flash Extender 46

Flash Photography 11, 13, 18, 21, 37, 38, 45, 46, 49–52, 57, 58, 63, 86

Focal Lengths 11, 14, 16, 17, 18, 20, 22, 32, 37, 46

Focus 14, 32, 33, 56, 57, 58, 85

H

Handling Camera 41–42

Histogram 35–36

I

Image Processing 13, 22, 34, 26, 47, 93

ISO 30, 34, 52, 53, 57

J

JPEG 15, 25, 26, 91, 93

L

Lenses 11, 13, 14, 16–17, 20, 31, 48
 Image Stabilized 42
 Macro 17, 18, 20, 21, 57
 Normal 17, 37, 42, 46
 Teleconverter 17, 18, 20, 21, 22, 85, 90
 Telephoto 11, 14, 16–17, 18, 19, 20, 21, 22, 37, 40, 43, 46, 75, 84
 Wide-Angle 14, 16, 18, 20, 46, 55
 Zoom 12, 14, 16–17, 20, 21, 22, 37, 83

Lighting 34, 37, 39, 46

M

Macro Photography 57

Manual Exposure 88, 90

Manual Focus 42

Memory Cards 15, 20, 21, 22, 23, 47, 48, 92, 93

Metering 35, 40, 45, 52, 86, 88, 90

Monopods 46

N

Noise 34

P

Printers 24, 95

R

RAW 26, 91, 93

Reflectors 45, 58

Resolution 11, 12, 13, 14, 15, 25

S

Sensor 12, 14, 15, 25, 27, 29, 30, 32, 33, 34, 36, 48, 53

Shutter Priority 32, 53, 84

Shutter Release Cord 19, 22

Shutter Speed 28, 29, 30–31, 32, 33, 34, 36, 42, 43, 51, 52, 53–54, 57, 58, 84

Storage (of photo files) 22, 23

Squeaker Call 48

T

TIFF 25, 26, 93

Tripod 19–21, 43, 46, 73

V

Viewfinder 37, 38

W

Wildlife 20–22, 56, 57, 60–61

Z

Zoo 63